LEARNING TO DRAW
DRAWING TO LEARN

Canadian Cataloguing in Publication Data

Nash, Joanna
 Learning to draw, drawing to learn : the portrait

ISBN 1 - 895854 - 12 - 1

 1. Portrait drawing – Technique. 2. Portrait drawing
– Problems, exercise, etc. I. Title.

NC773.N37 1995 743'.42 C95–940332-9

If you would like to receive our current catalogue and announcements
of new titles, please send your name and address to:
ROBERT DAVIES PUBLISHING,
P.O. Box 702, Outremont, Quebec, Canada H2V 4N6

LEARNING TO DRAW
DRAWING TO LEARN

PORTRAITS

by Joanna Nash

R O B E R T D A V I E S P U B L I S H I N G
MONTREAL/TORONTO

ISBN 1–895854–12–1

Text by Joanna Nash
Cover,book design & production: Mary Hughson
Proofreader: Aislinn Mosher

This book may be ordered in Canada from
General Distribution Services,

☎ 1–800–387–0141 / 1–800–387–0172 FAX 1–416–445–5967;

in the U.S.A., toll-free 1–800–805–1083;
or from the publisher, toll free across North America
1–800–481–2440, FAX 514–481–9973

The publisher takes this opportunity to thank the Canada Council and the Ministère de la
Culture du Québec for their continuing support.

Cover illustration: Portrait of Stephen Barry pastel, 1992, Private Collection
by Joanna Nash

TABLE OF CONTENTS

ACKNOWLEDGEMENTS

The book is somewhat like a reworked drawing. It contains original elements from my first book *J'apprends à dessiner: l'art pratique du portrait*, plus additional material, both visual and explanatory. In the intervening years between books I have deepened my understanding about the means and meaning of drawing and wish to share my experience as an artist and teacher with those who are curious and motivated to learn.

I want to thank a number of people who have been helpful to me: my patient and understanding fellow adventurers – my students, and two individuals I have had the privilege of working with, Bernard Chaet and G. Tondino, who provide role models for the teacher I would be proud to become. I also wish to thank Kay Aubanel, a friend, artist and teacher with whom I have had many fruitful exchanges about art. And, many thanks to Sigrun Schroeter who directed a perceptive and critical eye to this text and to Mary Hughson for her informed technical assistance.

Joanna Nash
Montreal, 1995

INTRODUCTION

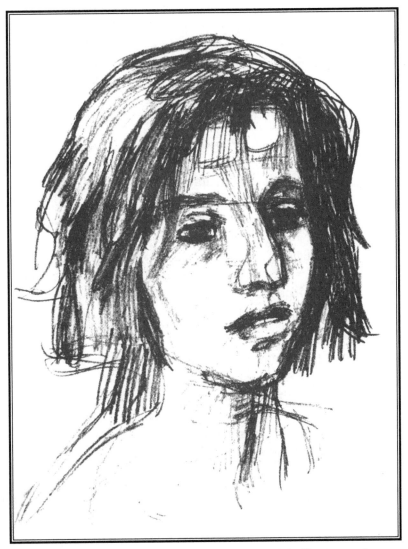

Fig. 0-1 Oskar Kokoschka *Girl's Head (Ruth Landshoff)* lithograph 1922

Drawing is often described as the most immediate graphic process. Its simplicity of means permits an instantaneous connection between feeling and action. This is not to say that speed is obligatory, but rather, a possibility to be explored. Drawing can range from a minimal use of line in rendering a simple sketch, to a heavily encrusted and scraped-back layering of chalk and liquid media. A drawing can be made on paper, wood, sand, cloth etc…; it can leave a dry or wet smear of matter on a soft surface, be scratched onto a hard surface, or be tattooed into skin. To define drawing narrowly would be incorrect; its range is vast and its possibilities numerous.

In composing this book, my choices were to cover a broad area superficially, or to look in depth at one aspect of drawing. I have chosen to do the latter: to concentrate on the drawing of faces with the most basic of materials. I consider drawing a process rather than a technique because it has the power to affect an exchange between the artist, the sitter, the product, and the viewer. It empathetically connects the artist and the subject of the drawing, it allows the drawing to communicate to the viewer, it links feelings to ideas, and finally, it permits intention to take on material form. In addition to this multi-faceted process, drawing is a life-long endeavor that develops and changes with the artist, and affects developments and changes upon the artist. Drawing can be descriptive, interpretive, concrete, elusive, subtle, and powerful.

My own drawing and my teaching of drawing are an integrated experience – thereby teaching and learning have become one. As a result, there are days when my students learn something, and days when I learn something. I am frequently asked if I get bored repeating the same things over and over, but I have found that nothing is repeated in quite the same way when drawing and life are viewed as a continuously evolving process.

As my teaching changes, my learning gains depth. Repeating the fundamentals gives me a grounding in my artistic and life endeavors. When I stop drawing I lose a sense of purpose, and when I stop teaching I lose a means of communication, therefore I am enriched by both experiences. Often I am asked: " Can you teach me to draw? " I respond by asking such students what they do for a living. If, for

example, the student is a chef, I might ask her if she could teach me to cook. "Yes," she might answer. "You need good tools, a few recipes, and the willingness to learn." "Could you make me into a great chef?" I ask. "No," is the usual reply. And so the student has answered her own question. Discovering that one already knows the answer is a lesson in itself.

When students ask me what to draw I usually tell them to draw anything that interests them; and when they ask me when to draw I tell them anytime will do as long as they draw in the present. I want them to be momentary and to grasp that drawing provides the potential to react to moments: little beads of time and opportunity strung together within our grasp but slippery to hold onto.

Cecil, my cat grasps many more moments of his life than I do of mine. He lives his moments completely: the satisfying ones when another cat grooms him, and the frightening ones when he is confronted by the vacuum cleaner. To 'Cess' there are no unseen, unfelt moments; he is aware of them all and his destiny is to use his instinct and experience to live as many as possible. We rational humans are further evolved than 'Cess'– in lieu of instinct we developed intuition – a capacity I would define as connected knowing: knowledge which comes from experience, feelings, and common sense. But somewhere in the development of humankind we have separated into split beings; often our thoughts and feelings are out of sync. By no longer trusting our intuition (which is our personal intelligence) we limit ourselves and contribute to feelings of alienation. How then can we go about becoming whole?

Many different practices aim at just this integration of body, soul, and mind, and our curiosity and self-awareness can direct us in choosing a discipline. Implicit in the notion of a practice is the commitment to its goals and methodology. For an initiate the best practice is simple and uncomplicated (although it may become more elaborate as time goes on). But, simplicity should not be confused with easiness.

This book points to one kind of practice: drawing from life – in a way that involves your observations and feelings, your individuality, and your intuition. You will call upon these components to help you produce drawings, and to experience an enhanced awareness of yourself as an artistically creative person.

HOW TO USE THIS BOOK

Scan the whole book, read Chapter 10, and review each chapter before beginning the exercises. If you are working alone, be prepared to do your exercises in a public place, ask friends or family to model for you, and frequently do self portraits for long exercises. It is optimum to put aside 3 hours a week to work through one chapter, as well as supplemental time sketching people at home, at work, or in public places.

Another option is to organize a group of people to sketch together at 3-hour weekly sessions. A group of 3 – 15 people working in an adequate space, with one member organizing the hiring of models, setting up the props and lighting etc... would be ideal (see materials section for lighting and props). Members of the group are advised to read each chapter before the session begins so that they are well prepared for the exercises, models, and props. Time can be put aside to discuss progress, and to participate in mutual constructive criticism. If the group can afford it, artist/teachers can be hired every month or so to check on the progress of the work. Their consulting fee can be shared by the group.

Art teachers having no previous experience teaching introductory portraiture will find the book helpful and suitable for teaching beginners, or those with some experience in drawing. The book presents a 12 week course of study in the studio, homework, and one final group session in a public place. Students should supplement their classes with one or two completed 12.7 cm x 20.32 cm (5"x 8") sketchbooks and the home exercises.

A detailed bibliography in the back of the book elaborates upon art books and specific artists relevant to the subject.

LANGUAGE, MATERIALS, MODELS, AND ALERTNESS

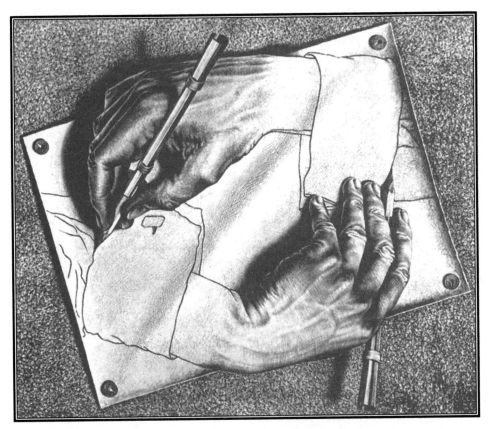

Fig. 1–1 M. C. Escher *Drawing Hands* lithograph 1948

The important thing about any word is how you understand it.
– Publilius Syrus: Maxims

Part One – Language

It is helpful when working together to use a simple and commonly understood vocabulary. I referred to the Oxford dictionary and to a number of art books mentioned in the bibliography when compiling these definitions.

LINE
A threadlike stroke that can be thin, thick, pale, dark, continuous, broken, straight, curved... and it can:

– represent the edges of an object (and be called an OUTLINE)
– divide and separate space creating boundaries
– lead the eye in directions and thus create movement
– vibrate rhythmically
– repeat itself in patterns
– congregate in diverse configurations to yield textures

FORM
The shape, mass or volume of something. For example:

– the form of an egg is oval
– the shape of an egg is an oval form
– an egg is an oval mass ("mass" implies a bulkier, weightier form)
 Confused? so is the chicken!

SPACE
A distance or an area that can be:

– the full surface of your drawing paper
– the area around a form
– the area between two or more forms
– the area contained inside the boundaries of a form, then it is called:
 POSITIVE SPACE.
– the area(s) outside the boundaries of a form, then it is called:
 NEGATIVE SPACE.

FORMAT
The proportions of your surface area, a vertical format is higher than wide, a horizontal format is wider than high.

TONE

Refers to the quality of gray shading in black and white drawings. Gradations of tone are called VALUES and they form a scale from white to black. Light or high values are closer to the white end, while dark or low values are closer to the black. A five value tonal scale would be: White – light gray – middle gray – dark gray – black. A TONAL DRAWING is generally made up of contrasting gray values and a minimum of line.

TEXTURE

Refers to the tactile quality of a drawing; the smooth or rough grain of the surface.

FORMAL ELEMENTS OF A DRAWING

Refers to the forms, lines, spaces, textures that constitute the visual components.

CONTENT

Refers to the subject matter.

OBJECTIVE DRAWING

Drawing that results from observation of surrounding realities.

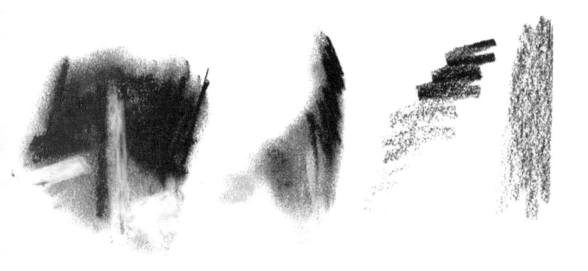

There are no limitations regarding the kind of materials that may be used in drawing, no regulations concerning their use or combination. The most unorthodox material means may shape a graphic statement as valid, as powerful as those created from the accepted repertory. To realize the form of a specific idea, it maybe indeed necessary to contrive original or unusual means. The process can work the other way as well. New materials will often pique imagination to fresh invention and stimulate perception. Always, however, there is the danger of method and materials becoming a rather comfortable preoccupation, of unusual media being a substitute for original vision; to use the familiar phrase – of means becoming the end. – Edward Hill

Part Two – Materials

The following are basic materials that can be obtained at any
art supply store:

EASEL (optional but recommended)
A sturdy floor easel made of wood with an adjustable horizontal height
bar can be built by anyone with basic carpentry skills (study the models
at the art supply store), or purchase a wood or aluminum one.
Drawing at an easel allows freedom of movement, gesture, and
mobility. When working without an easel, sit on a chair. Lean a
drawing board against the back of another chair in front of you. Rest
the bottom of the drawing board on your lap.

DRAWING BOARD
I recommend a sturdy board at least 61 cm x 76 cm (24" x 30") made
of 1.27 cm (1/2") plywood, masonite, chipboard or thick foamcore,
with two big metal clips to hold paper in place.

PAPER
Use 45.7cm x 60.9cm (18" x 24") Cartridge paper (sometimes called
bond) for warm–ups, exercises, slower studies and homework (up to 24
sheets might be used in a 3 hour session of quick poses). Obtain
100–150 sheets – loose or in pads, and if you work in a group try to
obtain it in bulk from paper distributors. For more developed
drawings, and those using paint or ink, get 8–10 sheets of 2 ply Mayfair
paper. Also get 4–6 sheets of an inexpensive middle gray paper, and 6
sheets of yellowish Manila paper. All of the above papers are made of
wood pulp and will deteriorate over time. They are, however, cheap
and adequate for beginners. As students become more competent they
might research moderately priced acid-free papers for their more
important drawings. Used sketches can be recycled like other forms of
paper.

SKETCHBOOK
Get a 12.7cm x 20.3 cm (5" x 8") wirebound, with all-purpose paper.

GRAPHITE

This is a form of carbon which we incorrectly call lead. It is the material commonly used to make pencils. All forms of graphite adhere to the following scale:

Hard and light …8H…6H…lH…HB…lB…3B…6B…8B…Soft and dark

It is available in the following formats, all of which are recommended:

GRAPHITE PENCILS

These look like thick pencils with an outer casing of wood or plastic. If they have no outer casing you can purchase a metal holder. Graphite can be sharpened with a wide-entry sharpener, sandpaper, a penknife, or X-acto knife. Get an HB, 3B and a 6B.

GRAPHITE STICKS

These blend well with the pencils, cover a large surface area, and create varied textures. They are rectangular blocks usually .63 cm x 7.6 cm (1/4" x 3"). Get a 3B and a 6 or 8B.

CHARCOAL

Is an ancient material made out of carbonized wood, usually from the willow tree. It is important to obtain charcoal which is soft and black. Avoid the thinnest willow charcoal and get 6 sturdy sticks about .63 cm (1/4") in diameter: square or round.

COMPRESSED CHARCOAL

Is denser and blacker than ordinary charcoal and useful for shading. Get 2–3 rectangular blocks which are about 7.6 cm (3") long and 1.3 cm (1/2") thick.

CONTÉ

This is similar to charcoal but denser and richer in texture. Get 2 sticks each of black, sanguine (orange or brown), and white. If you get individual round formats check to see if they fit into your graphite holder. Make sure the conté is soft (try it out in the store if possible, dry scratchy chalks are useless).

WAX CRAYONS (Crayola)

A box of 6 in various colours.

CHARCOAL ERASER (kneaded eraser)

This is a soft, putty-like eraser in a square shape usually 2.5cm x 2.5 cm (1" x 1") or bigger, which can be kneaded when warm to expose clean areas. Get two.

HARD RUBBER ERASER

This is an ordinary eraser – look for the pink Pearl brand.

CARDBOARD VIEWER

This viewer is used in composition exercises; to make one take a 12.7 cm x 15.2 cm (5" x 6") piece of stiff cardboard and cut a 6.4 cm x 8.9 cm (2 1/2" x 3 1/2") window out of the center. Or, use a 35mm photographic plastic slide casing (empty).

PAPER STUMPS (optional)

These are tightly rolled, pencil-shaped tools made out of paper or felt. Usually gray and about 7.6 cm x 12.7 cm (3" – 5") long, they are used to smooth or blend textures.

WATERBASED PAINT

Get a tube of dark, inexpensive gouache, tempera or watercolour.

INK

Get a small bottle of permanent lightfast ink, in a dark colour, either India ink, Chinese ink, or a fountain pen variety, and an eye dropper if there is none attached to the stopper.

PEN

A steel-point pen which dips into the ink bottle. The pen shaft is usually wood or plastic and different sized nibs (speedball variety) can be purchased to fit into the handle. An alternative is a sharpened twig or the sharpened end of an old wooden paint brush. Also get a few permanent lightfast felt pens with various sizes of tips.

BRUSHES

Any old brushes you might have (stiff and soft haired) which are not too big (less than 3.8 cm (1 1/2") wide). Inexpensive squirrel hair brushes with bamboo handles are available in Chinese shops (gently pull on the hairs and choose the brush which does not lose any).

PENCIL SHARPENER

X-acto knife or sandpaper for keeping points sharp.

PORTFOLIO

A cardboard folder, useful in transporting paper (so it does not have to be rolled), can be constructed by taping two 60.9 cm 76.2 cm (24" x 30") pieces of stiff cardboard together at one wide end. Handles can be stapled onto the top, or it can be fastened by a wide clip. To make it waterproof stick an adhesive plastic on the outside. If the portfolio is rigid enough it can double as a drawing board (in this case omit the handles). Alternatively, ready made plastic or cardboard portfolios can be purchased at art supply stores.

RAGS

Lint-free cotton or soft rags are helpful for blending and creating textures.

MISCELLANEOUS ITEMS

Moist tissues (the baby bottom variety from the drugstore, excellent for cleaning hands after drawing sessions), sharpened twigs, cloth, sponges, forks, combs, bits of wood, scrapers, feathers, (your fingers) etc... anything which can be dipped into ink or paint. The objective is to use any tool able to make interesting marks on paper. Get empty jars or containers for water, a couple of white styrofoam trays or white ice cube trays for use as ink and paint palettes, and a roll of paper towels.

PROPS

A small table and stool, an electric fan, masking tape, thumbtacks and straight pins, and props such as: 3–4 hats for models, patterned cloth, ribbons, balloons, scarves, crepe paper streamers, fans, drinking glasses, and other still-life objects needed for Chapter 8.

SPOTLIGHT

A 75–150 watt spotlight with a metal reflector, either clip-on or mounted on a tripod, and a long extension cord.

Part Three – Models

The model is an important participant in portrait drawing and should be treated with respect and consideration. Much of the success of a drawing session depends upon the collaborative relationship between the model and participants. Do not select models randomly; self-assured models help put novices at ease, and a good model is reliable,

adaptable to the situation, and capable of a focused relaxation or an expressive tension. There are advantages to hiring professionals, but individuals who are interested in posing can be trained as models. Always be on the look out for a potential model, someone who is interesting to look at and relaxed.

A good model projects her/his features and character. Certain models are suited to specific exercises because of their looks, temperament, or related skills such as acting or mime. Once I get to know a model I can plan specific exercises around his/her particular character or physical qualities. The looks of certain models sometimes suggest a specific approach to drawing. Some artists find it helpful to draw a variety of different looking models, (young, old, male, female, exotic, conventional...) others find working with one model (or self-portraits)

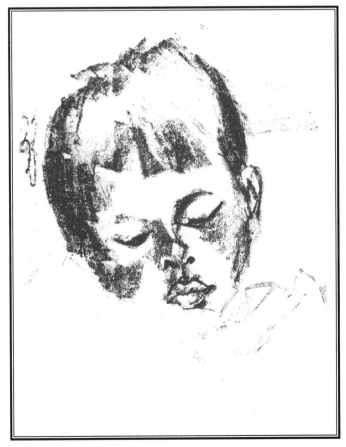

Fig. 1-2
Max Pechstein
Head of a Child
lithograph 1916

over a long period of time can be rewarding. Remember that you are your most accessible and revealing model.

When doing self-portraits make sure the physical set up is convenient. Experiment with positioning the mirror so that you are drawing comfortably. Initially try setting up the mirror and drawing board at the same height so you are not continually turning your head.

HOMEWORK ASSIGNMENT

You need 1 egg and a thin tipped felt pen.

This exercise will help prepare you for drawing the head. For our purposes the egg will represent your head, so visualize an imaginary line drawn up the middle of your face, along the middle of the crown of your head, and down the middle of the back of your head. Take your marker and draw this line all around the center of the vertical axis of the egg. Notice how the line curves to conform to the volume (thickness) of the egg. Now, visualize a line passing under your nose, by your ears, and all the way around your head. With your marker draw this circular line (saggital) and let it divide the previous line in half horizontally at right angles. Notice that this line appears curved as it communicates the roundness of the egg. Finally, imagine that you have a thin headband tied around the top part of your head. Draw this line around the top of the egg. See Fig. 1–3.

Still drawing on the egg, lightly sketch in geometric shapes to represent eyes, nose and mouth. Tilt the egg to the left and right and imagine how your head and features tilt accordingly. Also tilt the egg forward, as if you were looking down, and notice if the shapes drawn on the egg change. What happens? Then, tilt the egg as if your head was bending backwards; what happens to the overall shape of the egg at the crown and chin? These changing visual effects called *foreshortening* will be discussed later. For now just notice them.

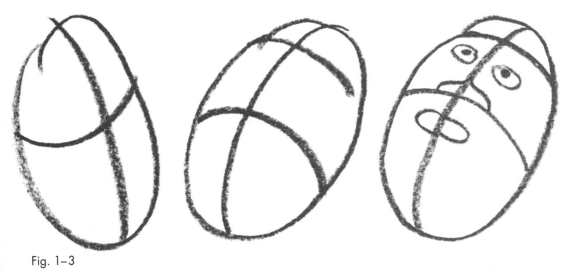

Fig. 1–3

Part Four – Alertness

Good drawing requires sustained concentration so that you are mentally and physically alert and ready to react to activity and situations in front of you. This is a difficult state to maintain and it is helpful to have a technique to focus you on the present.

PHYSICAL WARM-UP
5 minutes

Shake both hands vigorously at the wrists, as if trying to shake them off, then wriggle and bend your fingers in many different directions. Next, swing one arm in large circles from the shoulder a few times. Change directions. Do this with the other arm, and stop. Let your head rotate slowly in a wide circle leading from the crown of the head, around to one shoulder, down to the collar bone, around to the other shoulder, then up again. Do this slowly 2 or 3 times in each direction.

Slowly bend your head forward and down, slightly bending your knees and letting your fingers reach down towards your toes. (Drop your head forward, totally relaxed, towards your feet). Feel the weight of your head and arms stretch your spine. Hang there a few moments (knees bent if necessary), then slowly roll back up your spine with your head straightening up last. A good counter stretch is to put your hands on your lower back (covering the kidneys) and letting your head and neck drop back. These bends help to relax the spine.

DRAWING WARM-UP
5 minutes

Attach about 20 sheets of paper to your drawing board and try out all your dry materials: graphite, charcoal, compressed charcoal, conté, and crayons. Draw ovals on a page, letting the origin of the motion begin in your shoulder. Instead of drawing one clean outline superimpose many lightly sketched outlines, pressing a bit harder as you sense the shape take form on the page. Note the pressure of your tool on the paper. It is you who controls the lightness or heaviness of a mark; sketch lightly when you are uncertain, darker when you feel sure. Draw ovals on different parts of the page, repeating the outline until you feel the ovalness of the shape. Change the size of the ovals and the directions they are tilted in – make some rounder and others flatter.

If your shoulder tenses up, stop drawing and do some arm rotations. Take time to check the height of the horizontal bar of the easel. To avoid reaching far above eye level, arrange the height bar so that your eyes are at mid level of the drawing board. When you need to reach the top or bottom of the page just rearrange the bar. Turn over your page when it is filled with ovals, and repeat the same exercise with circles, letting the movements originate in the shoulder.

Experiment with different ways of holding the drawing tools, moving them around your hand to find the most comfortable grasp – firm but relaxed. Believe that you are capable of depositing a convincing mark on the paper as you vary the sizes of the circles, and the degree of pressure on the page, drawing some shapes lightly and others darker. As your second sheet fills up, detach it and let it drop to the floor– papers can be rearranged during the breaks.

The entire warm-up usually takes 10 minutes, but don't hesitate to take more time if necessary. If you are distracted or unable to relax after a few minutes of drawing, repeat part of the physical or drawing warm-up. It is worth relaxing and focusing at the beginning of a session rather than being distracted and tense throughout. Tired or sore eyes will affect drawing, so be attentive to how you see; insufficient light, physical tension or fatigue may be problematic. Some students have trouble alternating their focus from the model in the distance to the page close up, so they use bifocals to improve the transitions. If you are straining to see, move closer to the model and do what you can to be physically at ease and emotionally alert while you draw. You cannot control the model or other participants, but you can organize and prepare yourself optimally.

EGG HEAD AND THE GEOMETRIC HEAD

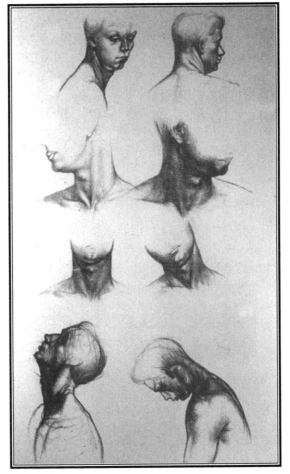

Fig. 2–1 Jeno Barksay *Heads* charcoal 1942

Each profile is actually the outer evidence of the inner interior mass; each is the perceptible surface of a deep section, like the slices of a melon, so that if one is faithful to the accuracy of these profiles, the reality of the model, instead of being a superficial reproduction, seems to emanate from within. The solidity of the whole, the accuracy of plan, and the veritable life of a work of art, proceed therefrom. – Auguste Rodin

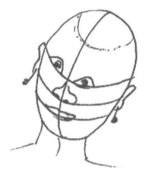

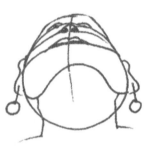

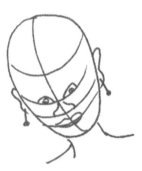

For this session hire a model with long hair parted centrally along the crown of the head all the way to the nape of the neck (two pinned up braids are ideal). Ask the model to wear clothes that expose the neck and the top of the shoulders, or to pose bare chested. Arrange chairs and easels in a circle with the group approximately 1 to 1.5 metres (3 to 5 feet) from the model.

If you are right-handed, angle your easel and left shoulder to the right of the model (reverse if left-handed), The view must be unobstructed. Center the drawing board and paper a little below eye level, and stand slightly less than arm's length away from the easel so that the model is visible just to the left of the paper. This allows you to shift your gaze from model to paper and back in quick, effortless eye movements, avoiding unnecessary turning of your head. Imagine how tired your head and neck would be after a 3-hour ping-pong game. Physical comfort is very important if you want to work well in a long drawing session.

While the model is posing don't waste valuable seconds turning pages; when one page is full, either flip it over the top of the easel or release it from under its clips and let it fall to the floor. Used sheets can be rearranged during the model's breaks and you can sketch on the reverse sides. After a few hours you will become accustomed to this rapid style and will adapt work methods to suit your needs. Another good habit to develop is stepping back a foot or so every few minutes to examine your drawing from a distance – you will be able to gauge your proportions more accurately.

The following exercises involve a sequential build up of elements. It is important to work steadily and vigorously (except when exercises are specified as slow). Speed is not detrimental to your work. In fact, it helps you to develop awareness and decisiveness. All exercises can be done without a model by going to an active public place full of people (read Chapter 10 before setting out).

Figs. 2–2

EXERCISE 1
5 minutes

> *Be sure that the model rotates a few degrees after each pose so that everyone has a changing view.*

Use graphite or conté on cartridge paper.

Set up the room, introduce the model to the group and ask him/her to take twenty poses of 10 seconds each, keeping his/her head level. Be sure that the model rotates a few degrees after each pose so that everyone has a changing view.

Visualize the model's head as if it were the egg you examined at home. Ignore all distractions and concentrate on drawing the changing oval shapes as the head changes position. Relax your grip on your pencil and let arm movements originate in the shoulder. Some people find it helpful to rest the edge of their hand or little finger on the paper while they sketch, although the risk of smudging the drawing is increased. Experiment – fill your page with 3 or 4 ovals sketched with lightly superimposed outlines, and make them the largest size that allows for relaxed arm movements.

EXERCISE 2
10 minutes

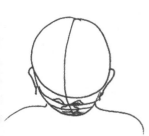

Fig. 2–2

Same materials.

Have the model continue holding similar poses keeping them 15 seconds each, periodically tilting to the right or left, but not forward or backward. Now, in addition to drawing the oval shape of the head, add the imaginary line that flows from the top of the head to the base, just as you did with the egg. Draw this line as it passes between the eyes, along the nose, over the lips, and down the middle of the chin. If you are looking at the back of the head, draw the parted hair from the top of the head down towards the neck. If you see the model in profile (side view) sketch in this curved line along the side of the face, just in front of the nose. Recall the curved lines on the egg – draw curved lines to communicate the volume of the head. Notice that when the model tilts his/her head to the left or right, this central line tilts as well. See Fig. 2–3.

BREAK
5 minutes

Give the model a 5-minute break. Use this time to rearrange your papers in order to work on the reverse sides.

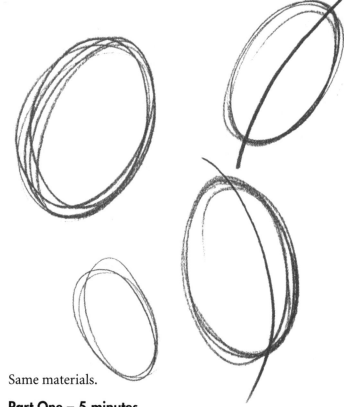

Fig. 2–3

EXERCISE 3
10 minutes

Same materials.

Part One – 5 minutes

Have the model hold similar poses for 20 seconds. Continue drawing the oval head shape and the line dividing the front or the back of the head in half, but now continue this line into the middle of the neck, so that the head appears to be suspended on a stem. Draw a continuous curved line that originates near the top of the head, runs down the middle of the face, and flows flexibly around the chin into the middle of the neck. Extend this important line where you estimate the model's spinal column to be: inside and under the cylindrical surface of the neck. Sketch this line a number of times, lightly and quickly, until it feels right. Sense the curve as you draw it, exaggerating if necessary.

The voluminous head is supported on this flexible line in much the same way as a blossom is supported on a stem; both the neck and the flower stem support weight and have the capacity to bend. From the back view this line passes under the base of the skull and into the neck. See Fig. 2–4.

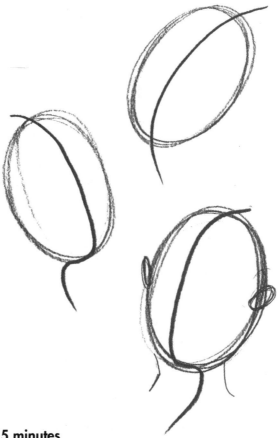

Fig.2–4

Part Two – 5 minutes

Ask the model to take ten, 30-second poses bending her/his head alternatively forwards and backwards to illustrate the effects of foreshortening. To draw in perspective means: to represent elements on a flat, two-dimensional surface (your page) as they would appear in three-dimensional space. Particularly note: changes in the relationship between the proportion of features, the shortening and lengthening of the oval, and changes in the width of the forehead and chin as the model bends his/her head forward and backward. Due to the visual effects of foreshortening, a feature may appear much closer or further from another than when normally juxtaposed. Draw it where you see it, and not where you think it ought to be. You will get more adept at foreshortening when you learn how to measure (Exercise 3, Chapter 4). Trust your eye and record what you see.

EXERCISE 4
10 minutes

Have the model extend the same type of poses to 45 seconds, and continue drawing the head (egg) and neck (stem). Geometrically the neck can be represented as a cylinder supporting the egg-shaped head. For the first few seconds take time to look at the outer contours of the neck, which lie on either side of the central stem. When drawing them be aware of how they join the head.

Notice how the neck changes shape with each new pose, and how the two sides often differ; one may curve while the other stays straight; one may shorten while the other lengthens. By now you are drawing the head, stem and the outer contours of the neck in 45 seconds. It doesn't matter if your sketches are messy.

In the next few poses we will add the ears and the jawline; think of the ears as circles or ovals that lie approximately halfway between the top of your skull and the bottom of your chin. Touch under your left ear lobe with the tip of your fingers and feel the beginning of the jaw bone with your thumb. Follow the line of the jaw as it curves towards the chin. Notice what kind of chin you have: pointed, round, flat, etc... Continue touching your jaw until you reach your right ear. This is the line we will draw next. See Fig. 2–5.

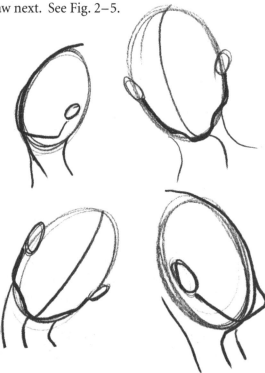

Fig. 2–5

EXERCISE 5
15 minutes

Use cartridge paper, conté and a bright coloured crayon.

Ask the model to take fifteen, 1-minute poses, rotating after each. For the first 30 seconds of each pose, sketch in these elements: the oval head, the central line which leads into the center of the neck stem, the cylindrical contours of the neck, and the ear(s). For the last 30 seconds, use your crayon to superimpose the pathway which defines the jaw. This line originates under one ear and follows the line of the jaw until you can no longer see it. If you see the model from behind, draw the hairline at the base of the skull instead. From the side, draw the jaw line only as far as you see the line curve. This coloured line indicates the character of the model's jaw and chin. Is it firm and angular or soft and round?

Information accumulates as you see more and see differently, and it is useful to show the modifications to your original lines as your understanding grows. The lightly sketched original lines remain visible as more specific lines are superimposed on top of them. These changes give character to the sketch, so don't worry about them showing.

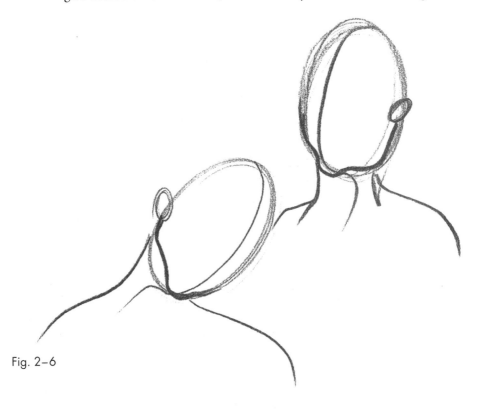

Fig. 2-6

EXERCISE 6
10 minutes

Use cartridge paper, conté or graphite.

Have the model take five, 2-minute poses. For the first minute sketch in the head and all the previous elements, including the ear(s) and shape of the jaw. Use the second minute to look at the neck contours, and notice how the neck merges with the torso: the cylindrical base of the neck widens gradually and curves along the trapezius muscle toward the slope of the shoulders. The neck contours do not end abruptly at the shoulders, but flow into a pathway leading into the upper torso and arms. See Fig. 2–6.

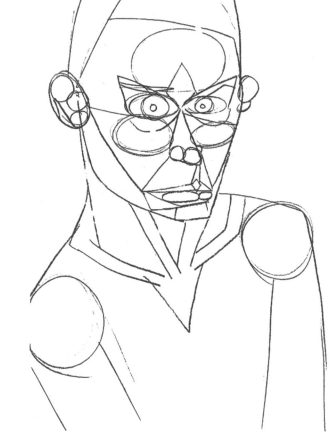

Fig. 2–7

15 minutes

Rearrange your papers, stretch and relax your neck and arm.

EXERCISE 7
20 minutes

If the group is large arrange an outer semi-circle of easels and an inner one of chairs.

Use graphite on cartridge paper.

The purpose of the next 2 exercises is to perceive the underlying geometric structure of the head and neck, and to increase your understanding of structure and proportions.

Have the model sit comfortably in one pose and tell him/her that the same pose will be repeated in the next sitting after a short break. Everyone should be positioned where s/he can see the front of the model's face. If the group is large, arrange an outer semi-circle of easels and an inner one of chairs.

Begin drawing a large 5 cm – 7.6 cm (2"–3") nose in the middle of the page and interpret it as a simple triangular shape, noting the proportions of the width of the base in relation to the height. Now, sketch outward from the nose, indicating all the forms and spaces that you encounter. Draw them as basic geometric shapes. Treat the neck and shoulders in the same way, interpreting shapes as circles, ovals, rectangles, trapezoids and triangles etc..

It is important to analyze and draw the spaces between and around the features, in order to understand facial proportions. These are the negative spaces of the human face and need to be carefully considered. Proceed by dividing up the model's face into large geometric shapes, then subdivide them into smaller geometric shapes (circles within triangles, squares within ovals, and so on…). Eventually the entire head, neck and shoulders will be fragmented into various geometric shapes so that it looks like a robot. See Fig. 2–7. Keep this drawing on your board and we will work on top of it after the break.

BREAK
5 minutes

This gives the model time to stretch as you walk around and look at other people's sketches.

The advantage of having others draw around you is that you can learn from their work and they from yours. Do not hide your sketches at the breaks; leave the last one on the floor or on your easel and encourage the others to do the same. If you see interesting techniques

being used, copy them; in fact copy anything you can learn from, then move on to new sources. Experiment now and your own style will develop in time. All artists learn from their mistakes, and the mistakes of others, in a trial and error fashion. To benefit from this learning experience don't hide your work, let the others learn from your sketches while you learn from theirs.

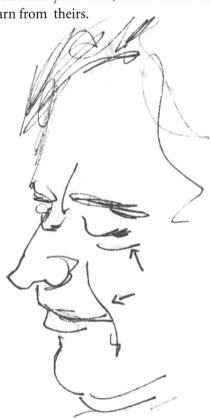

Fig. 2–8

EXERCISE 8
10 minutes

Notice where the lines originate and where they lead to...

Use a coloured crayon to superimpose on top of the previous sketch.

Have the model resume the previous pose. Using the coloured crayon superimpose all the creases, wrinkles and folds that you see between the features. Notice where the lines originate and where they lead to; they are pathways that connect one feature to another. To help you see these lines, ask the model to smile briefly. Think of aging the model by exaggerating these pathways. Do you see lines between the eyebrows? Lines connecting the nose and mouth? Lines under the eyes? Search them out, they add character to the drawing.

EXERCISE 9

20 minutes

> *Close your eyes...
> sensing the surface
> of the paper...
> Move slowly and
> randomly...*

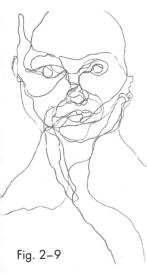

Fig. 2–9

> *... if you get lost,
> stop, close your
> eyes, feel your hand
> contact the paper,
> then open your eyes
> and continue
> drawing.*

Use sharpened graphite on cartridge paper.

Part One – 5 minutes

Close your eyes, hold your drawing board with your free hand, and sketch random lines on the page, sensing the surface of the paper. Vary the pressure of your lines, maintaining a slow rhythm. Do this whenever you want to reconnect the physical aspect of drawing, or when you need to focus your attention on the present. Then put down your chalk and slowly move the tip of a clean finger over the surface of your face, starting at your nose. Don't move with any particular plan, just let your fingers touch in a continuous winding fashion – vertically, horizontally and diagonally. Move slowly and randomly, feeling the voluminous landscape of your face.

Part Two – 15 minutes

This is a slow exercise; its purpose is to understand the sculpted surface of the face. It takes time to develop visual sensitivity. Slow down and take the time to: see, feel and draw.

Have the model take a comfortable pose. You want the sharp point of your pencil to move over the paper, as if it were an insect walking over the hills and valleys of the model's face. If you find it difficult to work this slowly, persevere. It is advisable for you to be adaptable in the speed of your work; drawing quickly when the situation calls for it, and slowly when appropriate – noticing details takes time.

It is important to maintain a sense of purpose in your exercises; it is easy to get distracted and to lose sight of your objective. If you get lost, stop, close your eyes, and feel your hand contact the paper. Then open your eyes and continue drawing. This moment of centering your thoughts and actions can renew the 'momentary' contact between you and your drawing. The finished drawing should look like the delicate cracks on the surface of an egg. See Fig 2–9.

BREAK
5 minutes

Circulate around the room looking at other people's drawings.

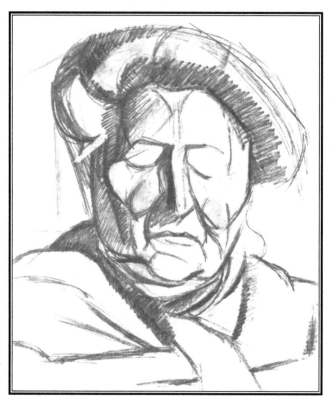

Fig. 2–10
Unberto Boccioni
Portrait of Boccioni's Mother
chalk & watercolour 1915–16

EXERCISE 10
15–30 minutes
(depending upon the time left in the session)

Use graphite or conté on cartridge paper.

Have the model take a comfortable pose, reading if desired, with his/her head bent slightly forward. Lightly sketch in guidelines to establish the head and neck, using the methods that have been developed in the preceding exercises. Keep these guidelines light so that they are visible but not distracting, and remember that it is alright to alter and add to them.

By this time you have studied the model for almost 3 hours. During this final pose, take time to think about the person you are sketching. Create a personality in your drawing; let yourself freely interpret and develop an interesting aspect of this individual. You do not have to like or dislike the model, just connect empathetically with him/her.

**HOMEWORK
ASSIGNMENT**
*15 minutes
or longer*

Read Chapter 10, then go to an active public place where people are milling about. Sketch egg-shaped heads, noting the movements of the head, neck and shoulders. Study the way that hair and hats change the shape of the head, and add this information on top of the egg shape. Work quickly, keep details to a minimum, and concentrate on drawing basic geometric masses. The sooner you break the ice by sketching in public, the sooner it will become a natural activity.

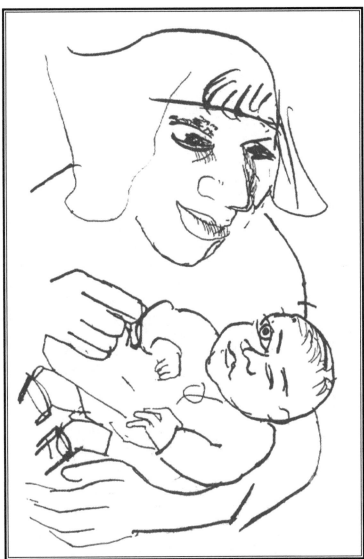

Fig. 2–11
Lucian Freud
Mother and baby
ink on brown paper 1949

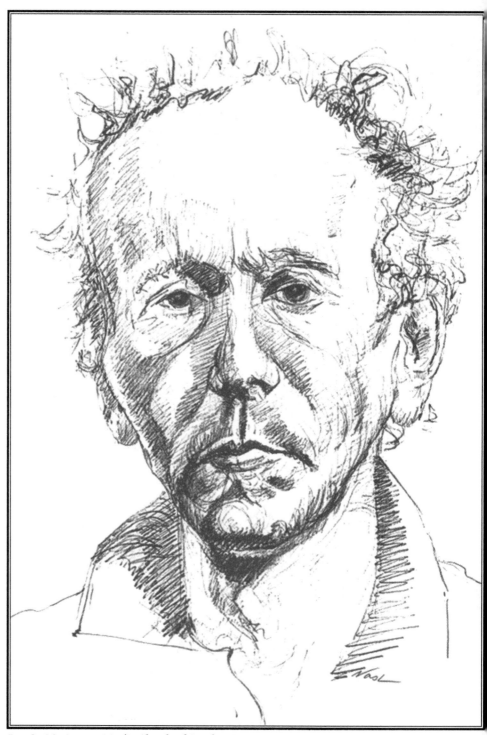

Fig. 2–12 Joanna Nash *Sketch of Stephen Barry* pencil 1988

KNOW YOUR NOSE

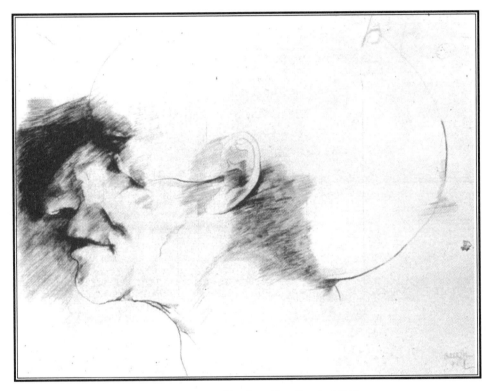

Fig. 3–1 Leonard Baskin *Fuseli* ink, 1968

Let Raphael and Titian draw the same nose, and their drawings will be totally unlike. You don't see with my eyes ! I don't see with yours. Let each see with his own, and let his attempt to render what he sees be respected. – William Morris Hunt

WARM-UP

5 minutes

Part One

Prepare for this session by doing the physical warm-up outlined in Chapter 1. Then, draw a long series of horizontal lines across a clean sheet of cartridge paper with each of the following: graphite pencil and block, conté, regular charcoal, compressed charcoal, and crayon. Start the lines at the left with hardly any pressure, and as you move towards the right use increased pressure, pressing as hard as you can at the end of the line on the right. What is revealed on the paper is the tonal range of each material. Notice how lightly the materials can mark the paper and how dense and dark they can get. Repeat these lines using the tips and the sides of the chalks. Your manual pressure controls the degree of lightness or darkness of the mark, and each material has its own tonal range. We will examine tone in greater depth in Chapter 7. See Fig. 3–2.

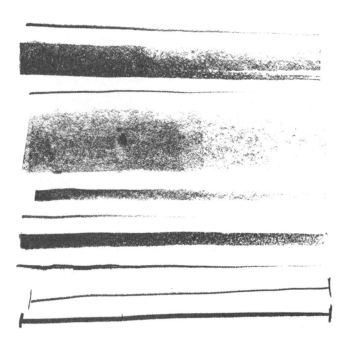

Fig. 3–2

Turn your attention to how you are holding the drawing tool… tightly?, passively? Adjust your grip until you are holding it firmly, yet gently. A grip that is too forceful can make you insensitive to the subtleties of line, whereas too passive a grip may result in marks that lack conviction.

EXERCISE 1

Part Two

Have the model take 30-second poses for 10 minutes, and as a review repeat Exercise 4 of Chapter 2.

LOCATE YOUR NOSE

Using your index finger and thumb, measure the distance from your hairline (forehead) to the tip of your nose. Compare this distance with that of the tip of your nose to the bottom of your chin. Is it almost the same? Very different? Establish a relationship. Then imagine a straight line connecting the bridge of your nose to the top of one ear. Touch this pathway slowly, using the tips of your fingers to travel over your eye and cheek.

Now touch the bottom of your nose, under your nostrils, and move out towards the bottom of your earlobe. Be aware that your face has volume, and that the imaginary lines you have traced are curved like those you drew on the surface of the egg. In the following exercises we will draw these pathways.

EXERCISE 2
5 minutes

After the warm-up arrange the easels in a circle around the model, as described in Chapter 2. Use graphite or conté on cartridge paper, and later a brightly coloured crayon. The objective of this exercise is to locate the general position of the nose, not to draw it in detail.

Have the model take ten, 30-second poses, remembering to rotate slightly after each pose. As in previous exercises, lightly and rapidly sketch the oval head and component parts, including ears, neck and shoulders. Now we will add a new component: with your coloured crayon superimpose the imaginary lines going from the top of the ear to the bridge of the nose, and from the bottom of the ear to the bottom of the nose (and further around if more of the model's face is in view). Once the lines are drawn, swiftly make a circle or triangle between them to indicate the general placement of the nose... but don't attempt to do its outline at this stage. See Fig. 3–3.

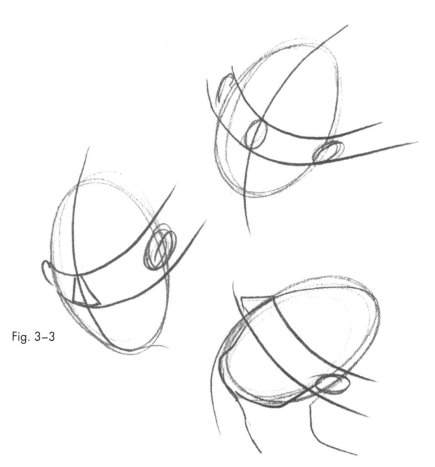

Fig. 3–3

EXERCISE 3
10 minutes

... make your changes over the original lines and let the information build up and be visible in the drawing...

Same materials but omit the coloured crayon.

Have the model take three, 3-minute poses, and repeat the previous exercise – but doing it more slowly and carefully this time. For the first minute of each pose draw the component parts of the face, including the circle or triangle which indicates the form and placement of the nose. Add the pathways from the top of the ear to the bridge of the nose (and further if you see it).

Sense this line as it moves over the facial landscape, climbing up the cheekbone, across the eye, up the steep slope of the side of the nose, along the plateau, and down the other side. Repeat this sensation with the imaginary line passing from the bottom of the ear to the bottom of the nose. The result looks like a mask on your model's face. You may want to relocate the position of your original nose (triangle or circle) after you have sketched in the lines, so make your changes over the original lines and let the information build up and be visible in the drawing.

It is important to establish how much the nose protrudes out from the face in profile views. Begin by sketching an oval head on your sheet, then step back from the easel and look at the model. We will use the following method to establish this protrusion. With one of your eyes closed, sight your pencil along the top angle of the nose which stretches between the forehead and the tip of the nose. Then sketch this straight angled line on the side of the oval head, and repeat the procedure adding the angle running between the tip of the nose and bottom of the chin. These are guidelines to indicate the protuberance of the nose. Once they are sketched in, lightly superimpose the actual shape of the nose on top. Do you recall the measuring of your own nose from hairline to tip of nose and tip of nose to chin? Approximate these two distances on the model – are they similar? Different? See Fig. 3–4.

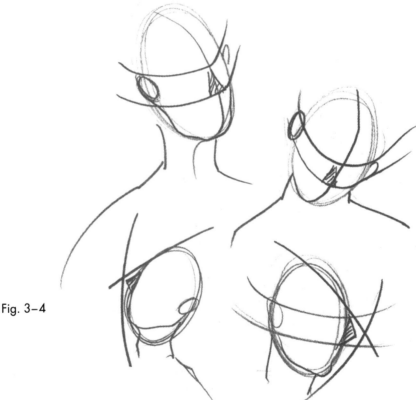

Fig. 3–4

Walk around and look at other people's sketches.

The next several exercises require a frontal view of the model from as close a proximity as possible. Arrange the easels in a close semi-circle facing the model (if necessary form an inner row of chairs, and an outer one of easels).

EXERCISE 4
20 minutes

Save this sketch or the next one to be reworked in Exercise 6.

Use graphite, or conté on cartridge paper.

Part One – 10 minutes

Save this sketch or the next one to be reworked in Exercise 6.

Have the model take a comfortable pose and draw the nose in careful detail, making it fairly big (at least 1/4 of your page). Work slowly and examine the structure of the nose. If you have time, shade in the nose by holding the chalk on its side and rubbing black onto the planes which recede (refer to Chapter 6 for shading techniques).

Part Two – 10 minutes

Change positions with another student and repeat the exercise, drawing a big detailed nose from another view point
(profile if your first was frontal, or vice-versa).

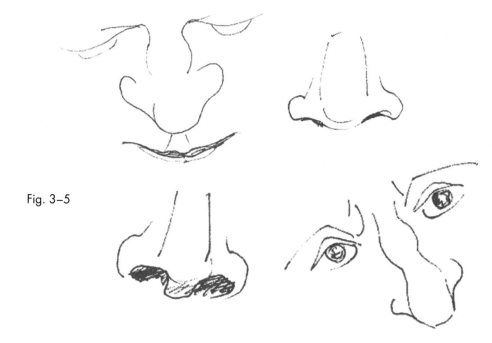

Fig. 3–5

Fig. 3–6

EXERCISE 5

Do this exercise slowly.

Do this exercise slowly.

Imagine the model wearing a pair of wire-rimmed glasses with a thin piece of metal passing over the bridge of the nose, connecting the two parts of the frame. With your coloured crayon, superimpose this imaginary line on the previously drawn nose. Develop this line slowly and sense how it curves to communicate the volume of the nose. Superimpose another line, slightly below the first, and notice if the nose is wider; curve your line accordingly.

Continue drawing a descending succession of these lines, sensing the changing of the nose volumes as your pencil climbs up the side, crosses the plateau, and then curves down towards the cheek on the opposite side. As you approach the lower section of the nose, indicate the curves of the nostril(s) as well. See Fig. 3–6.

Stretch, circulate, and look at the drawings of others.

BREAK

5 minutes

EXERCISE 6
5 minutes

Same materials.

The objective of this exercise is to sketch the nose in different positions along a vertical axis, in order to understand its foreshortening as we see it in perspective (three dimension). For this exercise have the model sit in a sturdy chair and support the back of his/her head with clasped hands.

The model begins by extending the neck fully backwards, exposing the underside of the chin. After a 30-second pause s/he lifts up his or her head slightly. In total the head shifts about 6 – 7 times before the face is vertical and upright, and 6 – 7 more shifts as the head bends forward towards the chest. Only sketch the nose and the nostrils, placing a series of noses in vertical rows down your page. As the head tilts forward look for the changing shape of the nose and the nostrils, particularly the increase or decrease in the length of the nose. See Fig. 3–7.

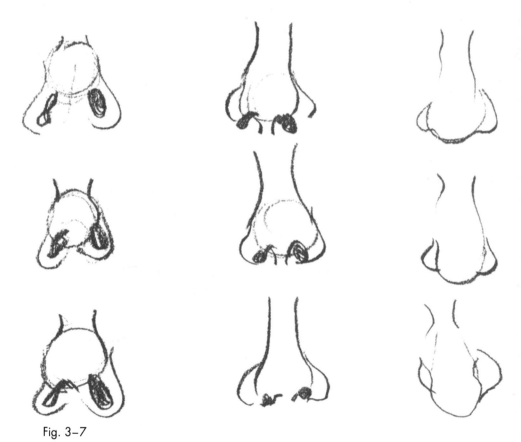

Fig. 3–7

EXERCISE 7
20 minutes

Use sharpened graphite on cartridge paper. Have the model take a comfortable seated pose and position yourselves in front.

This exercise explores the details of the facial landscape, and should be done slowly. It relates to Exercise 10 of Chapter 2, but in this case we work from the inside outward and your lines will radiate out from the nose towards the edges of the face. This method allows you to draw the face without squeezing or stretching the features to fit into a pre-defined oval.

> ... in this case we work from the inside outward and your lines will radiate out from the nose towards the edges of the face.

Begin by resting the side of your hand gently on the page. After a few moments of contact and of focusing on the model, draw the tip of the nose and sketch a line outward from this spot, keeping the graphite in constant contact with the surface of the paper. Draw slowly. After a few moments of exploration take a slightly different return pathway to the center of the nose – your point of origin. Repeat this process of venturing out and returning a number of times, sometimes moving up towards the eyes, then down towards the mouth, and then sideways to the edges of the face. The resulting sketch will be a network of overlapping lines radiating out from the nose, with shorter and longer lines as you explore the edges of the face. See Fig. 3–8.

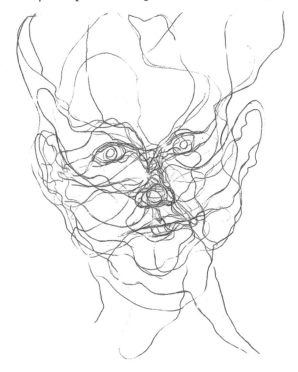

Fig. 3–8

BREAK
10 minutes

If you feel yourself getting lost in the drawing, or if your attention starts to wander, take a moment to close your eyes, breathe deeply and press your graphite tip to the paper until a sense of orientation and focus returns.

EXERCISE 8
20 minutes

Use conté on cartridge for part one and a coloured crayon for part two. Have the model resume a similar pose.

Part One – 10 minutes

Review Exercise 6, Chapter 2 – the geometric head. Afterwards draw the large geometric components of the model's head, neck and shoulders, and subdivide them into smaller geometric shapes. See Fig. 2–7.

Part Two – 10 minutes

Same pose. Use coloured crayon on the previous drawing.

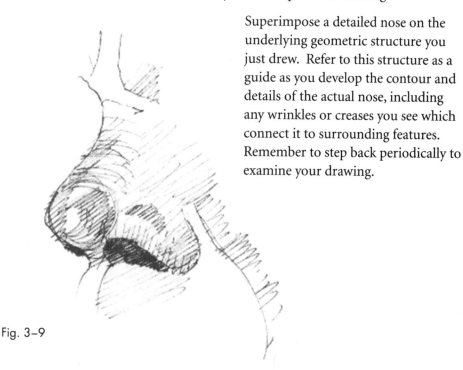

Superimpose a detailed nose on the underlying geometric structure you just drew. Refer to this structure as a guide as you develop the contour and details of the actual nose, including any wrinkles or creases you see which connect it to surrounding features. Remember to step back periodically to examine your drawing.

Fig. 3–9

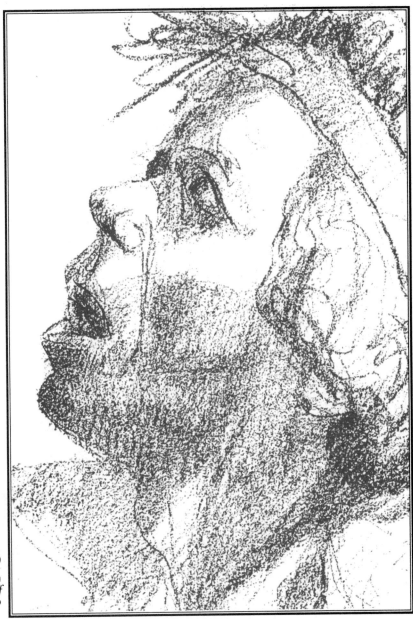

Fig. 3–10
Joanna Nash
Jeff
conté 1989

5 minutes

Fig. 3–11
Lucien Freud
The Painter's Father
pencil 1970

EXERCISE 9
30 – 40 minutes

Use conté on cartridge or mayfair paper.
Have the model take a comfortable seated pose,
perhaps reading with her/his head slightly bent forward.

By now you will be somewhat familiar with the model and will relate to the model as a personality. Study her/his head, body, posture and clothing, think about his/her name, and ask yourself what this person is like. Develop a sense of empathy towards this hardworking individual and let these thoughts guide you as you draw. Sketch in any way that appeals to you, developing some shadows if you see any, and periodically stepping back to look at your drawing.

HOMEWORK ASSIGNMENT

Repeat the homework assignment of Chapter 2, but this time choose a quieter place where people are relaxing – sitting or reading. Begin with the overall gesture of the head, neck and shoulders, then position and develop the nose and other features. Concentrate on discreetly drawing as many different noses that you see, some frontal others in profile.

WHERE ARE THEY LOOKING?
WHAT ARE THEY THINKING?

Fig. 4–1 Rembrandt *Self-portrait* circa 1627 pen, brush & bristre

The eyes are never alike... so we need not feel bad if...
one eye (is) higher than the other... – William Morris Hunt

The eyes are unique in their ability to animate a portrait. Feelings, emotions, character and thoughts are communicated by the eyes, and artists strive to describe these interior qualities as they describe the exterior features.

For the following exercises hire a model who has large, expressive eyes and wears no make-up.

WARM-UP

Do the 10-minute warm-up described in Chapter 1. Then, with clean fingers, examine the bony structure around your eyes. Find the bone under your eyebrows and move your fingers outward along this ridge to the temple, then inwards along the upper cheek bone beneath the eye toward the nose, then continue upwards until the circuit is completed. We will represent this whole eye structure as a circle, with the eyebrow curving along the top, and the long crease or wrinkle originating at the inside corner of the eye at the bottom.

The eyeball rests in the middle of this structure, and appears oval because the eyelids cover parts of it. A dark pupil lies in the middle of the coloured iris which in turn lies in the middle of a white area (the sclera). When the eyes are open the lids give an oval shape to the eyeball. As the eyes gradually close the oval becomes narrower. Closed eyelids have volume and indicate the round form of the eyeball underneath with eyelashes along the bottom.

Figs. 4–2

EXERCISE 1
5 minutes

Use conté or graphite on cartridge paper.

Arrange the easels and chairs in a semi-circle and have the model take 30-second standing poses, rotating after each. Begin by drawing the oval head with structural guidelines and the nose. Now, we will position the eyes along the line that joins the top of the ear(s) (which you indicated in Exercise 2, Chapter 3). To quickly represent the eyes, initially sketch them as two ovals or a horizontally drawn figure-eight. Notice the position of the eyes in relation to the nose and ears. See Fig. 4–3.

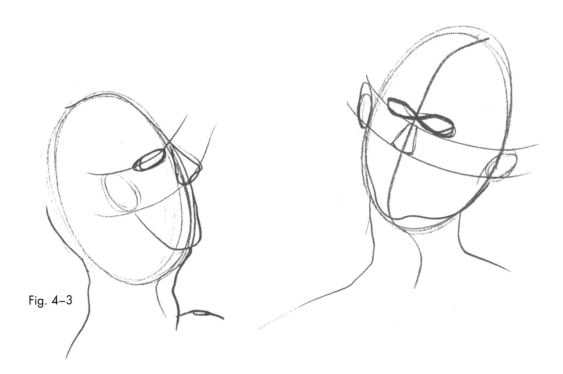

Fig. 4–3

EXERCISE 2
30 minutes

Use conté or graphite on cartridge paper.

Part One – 15 minutes

Ask the model to take a seated pose and position yourself in front or at the side of her/him, close enough to see at least one eye in detail. Begin by drawing a large, loosely rendered eye(s), keeping in mind the circle structure which we examined after the warm-up. Indicate the eyebrow(s) at the top of the circle, the crease(s) under and around the eyes, the eyeball(s) and the eyelid(s). Suggest the volume of the eye by adding some lights and darks. If you are drawing the model in profile, the distance between the eye and the ear is important. See Fig. 4–3.

Fig. 4–4

5 minutes

Walk around and look at drawings.

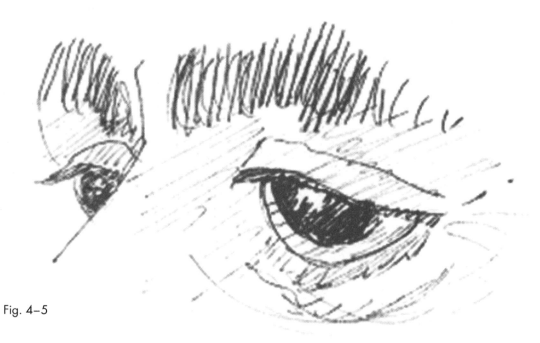

Fig. 4–5

Part Two

Same pose, same materials.

Exchange positions with another student, giving yourself a different view (side or front depending upon what view you just had). Notice how different the shape of the eye appears. When you draw, observe what is in front of you and try to make as few assumptions as possible; trust your sense of observation; trust your eye.

BREAK

5 minutes

During this break form a closer semi-circle so that everyone has a frontal view of both eyes. Set up a back row of easels and a front row of chairs if necessary.

EXERCISE 3

15 minutes

Hold a long pencil, brush, or stick (skewer) in your hand.

The objective of this exercise is to measure spatial relationships using a technique which will be elaborated upon in Exercise 4, Chapter 5.

This is a simple way to measure relative proportions. Step out from behind your easel to have an unobstructed space in front of you. Stretch out one arm in front of you, hold your pencil horizontally, and close one eye. Keep your elbow straight throughout the exercise. You will use your pencil as a ruler and your thumb as a marker on the pencil. For example, if you are right handed – close your left eye, hold the pencil near its left end, arm's length from your nose, and measure by moving your thumb slightly along the pencil shaft towards its right end. Sight the tip of the pencil on your view of the outside corner of the model's left eye. Slide your thumb along the pencil and mark off the distance between the tip of the pencil (lined up on the left corner of the eye) and the place where you see the right corner of the eye. This should result in a tiny distance marked off on your pencil which corresponds to the width of the left eye of the model.

... keep your elbow straight throughout the exercise... close one eye.

Now, keeping this distance marked off with your thumb, move your whole arm fractionally to the right, and compare the marked off width of the left eye with the distance between the eyes (that which bridges the nose). Estimate if the distance between the eyes is equal to, wider, or narrower than the width of the left eye. Is it the same distance? Different by a tiny bit? By a third of the distance? Approximate how much.

In this fashion we can estimate distances and compare proportions of different features and negative spaces. For example, compare the width of both eyes. Are they the same? Compare the width to the height of the left eye by measuring the width horizontally and then rotating your hand to measure the height vertically, and so on.

It is important to keep one eye closed and your elbow straight throughout or your measurements will be inaccurate.

Take some time to practice this measuring technique, during the next break with some objects in the room, and at home to become more adept at it. All features and negative spaces of the head, neck, and shoulders can be measured and compared in this fashion. It is important to keep one eye closed and your elbow straight throughout, or your measurements will be inaccurate.

EXERCISE 4
5 minutes

THE ROVING EYE

Compressed charcoal or conté on cartridge paper.
Maintain your frontal view.

For this exercise ask the model to project twenty, 10-second glances in different directions, tilting her/his head occasionally to the left or right. Our objective is to see how the pupil moves around the interior of the eye–therefore the model's head should remain relatively stable with the eyes doing the moving. Swiftly, establish the eyes as a unit – two circles or a figure-eight (as in Exercise 1 of this chapter). Then ask yourself where the model is looking, and quickly add two black dots to represent the position of the pupils. Repeat the procedure as the model shifts glances, noticing that when the head tilts to the left or right the eyes angle with it. In some of the poses the eyelids may cover part of the pupil(s), so alter their size accordingly.

Ask the model if s/he is capable of taking one cross-eyed position, and sketch it quickly. Because the eyes are animated by the activity of the pupils, we can suggest that the model is thinking by showing where her/his attention is directed. See Fig. 4–6.

Fig. 4–6

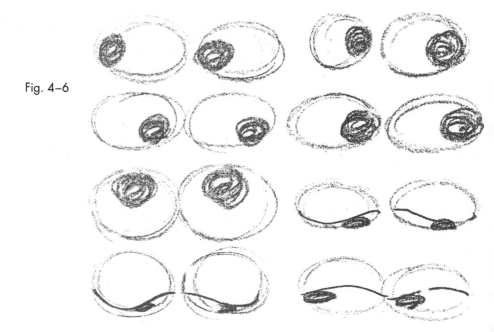

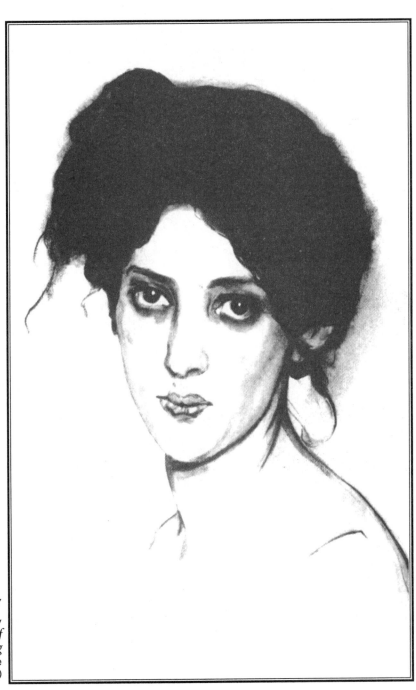

Fig. 4–7
Valentin Serov
Portrait of
Isabella Grünberg
pencil, watercolours & white
1910

Practice measuring objects.

BREAK
10 minutes

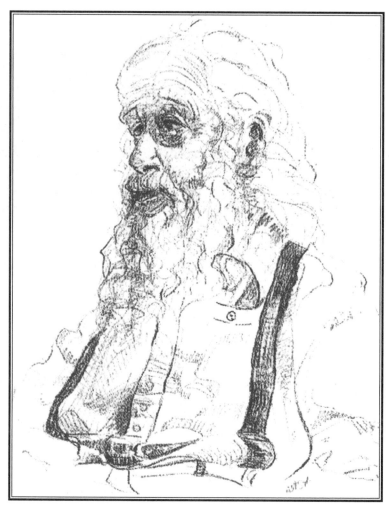

Fig. 4–8
Joanna Nash
Sketch of Charles
conté on paper 1990

EXERCISE 6
20 minutes

... *draw expansively* ... *work slowly*...

THE ACTIVE LINE

Sharpened graphite or conté on cartridge paper.

Have the model take a seated position and sit as close as possible in front of her/him. This time draw expansively, it does not matter if your drawing goes off the edges of the paper. Start by lightly drawing the nose then slowly moving up to the eyes. Work slowly and notice the spatial relationships between the eyes and the nose. We will examine the landscape of the face by moving the pencil slowly, as we did in Exercise 7 in Chapter 3.

Take your time to explore all the surface details. When you are uncertain about an area lighten your pressure on the drawing tool, when you understand the area and feel convinced of what is going on, press harder. Examine the shape of the eyes and how they appear in relation to the nose – especially at the bridge; add any creases you see connecting these features. If you have time make some excursions down towards the mouth, up to the hair line, and out towards the ears...

As you draw, concentrate on the model and do not spend too much time watching your hand perform. In the same way that a dancer does not look at her/his feet while dancing, trust your hand to respond to your commands. Your capacity to 'sense' your line moving on the paper frees you from the necessity of monitoring your hand, and allows you to visually focus on your subject. The coordination between your eyes and your hand will improve with practice.

Experience the sensation of your hand moving over the entire surface area of your paper. This is your performance arena, use it all – and vary your line: thin, thick, light, dark... When your eyes move to the top of the model's head and into the hair your hand can move off the top of the paper, suggesting the energy of the form continuing off the page. Respond to your emotional prompting. Allow some gestures and lines to expand off the page into space. When squeezing sections of your drawing inside the frame do so conscientiously for a visual reason or emotional impulse; don't do it because you feel everything must be contained in the page.

Your sense of proportion and capacity to design space effectively will be achieved in time (the chapter on composition will be helpful). For the moment draw expansively, and concentrate on retaining the relative proportions between features.

Periodically assess your state of mind, and regulate your drawing tempo. If you feel impatient and unfocused – relax, concentrate on the model and slow down; if you feel sluggish or bored – stretch your body, wake up and draw more vigorously.

BREAK
5 minutes

Look at other participant's sketches.

Fig. 4–9

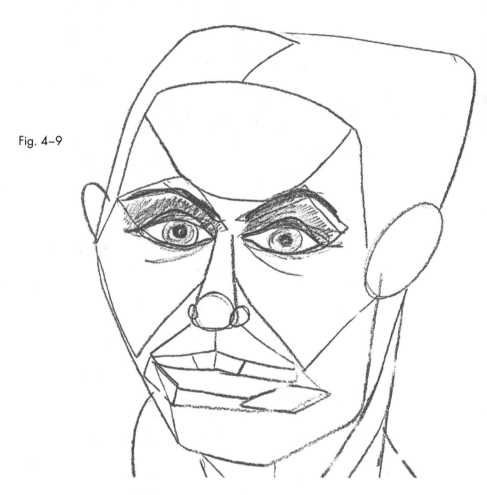

EXERCISE 7
20 minutes

Use conté on cartridge for part one and a coloured crayon for part two. Sit in front of the model.

Part One – 10 minutes

Review Exercise 11, Chapter 2/ the geometric head. Then draw in all the components you have sketched up to date including geometric shapes to represent the eyes. When you have finished drawing in the main shapes, subdivide them into smaller geometric shapes.

BREAK
5 minutes

Part Two – 10 minutes

Same pose.

Superimpose coloured crayon on the previous drawing. Sketch in detailed eyes on top of the geometric structures. See Fig. 4–9.

EXERCISE 8
30 – 40 minutes

Use any sketching material on mayfair paper. Have the model take a comfortable pose and draw a frontal or side view in any way you wish, paying particular attention to the eyes.

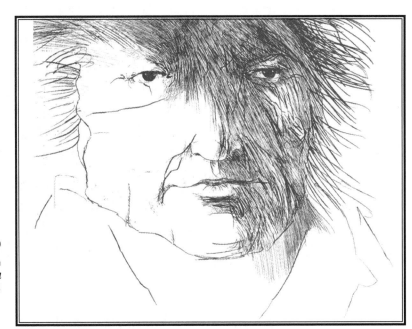

Fig. 4–10
Leonard Baskin
Francisco de Goya
etching, 1963

HOMEWORK ASSIGNMENT

If possible ask someone to pose for you, and repeat the homework of Chapter 2, focusing on the eyes. Ask your subject to keep her/his eyes focused on a specific spot and if the eyes wander, remind your model to look at the original place. In this exercise your objective is to show your model looking at something. Avoid giving them a vacant glassy expression.

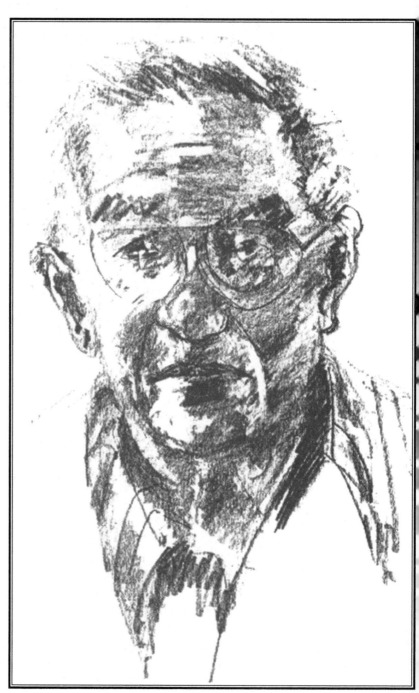

Fig. 4–11
Joanna Nash
Sensei Okimura
graphite on paper 1994

THE MOUTH AND FACIAL EXPRESSION

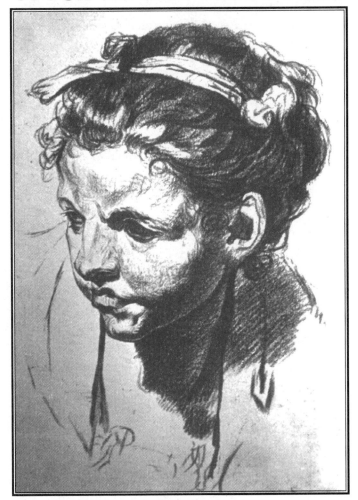

Fig. 5–1 Greuze *Study of a Woman* conté crayon, circa 1790

Be guided by feeling alone… reality is one part of art; feeling completes it… before any site and any object, abandon yourself to your first impression. If you have really been touched, you will convey to others the sincerity of your emotion. – Camille Corot

For this session hire a model experienced in acting or mime.

At home, look at your mouth in a mirror and utter several words. Your mouth assumes a variety of shapes and activates the lower part of your face. Open your mouth and move your jaw in different positions, noticing how this affects surrounding features. Touch your upper lip and feel three sections, one on either side of a central portion, then touch the two forms of your lower lip.

WARM-UP

Part One – 5 minutes

Repeat the hand exercises described in Chapter 1 (physical warm-up) and then tune into your body: are you standing or sitting comfortably? If not, be aware of your awkward position, then consciously correct your stance. Arrange your materials and adjust the height bar of the easel if necessary (if it is too high your arm will tire quickly). It is important to periodically take time to stretch and reposition yourself while you are drawing; your reward for being attentive to yourself is greater concentration as you work and enhanced artistic performance.

Part Two – 5 minutes

Use graphite or conté on cartridge paper.

Repeat the closed-eye exercise described in the warm-up in Chapter 4. As you move your chalk randomly over the paper, change speed and pressure. Allow yourself to draw animated lines; they are the channel through which you can convey your nervous energy and emotions. Vary the type of line, thin, thick etc…

Fig. 5–2

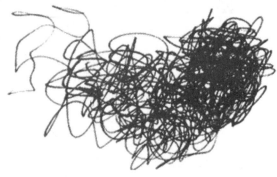

EXERCISE 1
15 minutes

Use conté or graphite on cartridge paper.

Arrange easels for a frontal view of the model and get as close as possible…(or arrange two semi-circles for a larger group).

Have the model take three different 5-minute poses and during the first minute or two of each, sketch in the oval head with all its components. Sketch lightly and interpret the features loosely without details. The mouth can be approximated by a banana-shaped form for the time being. Then, visualize (imagine) two vertical parallel lines on the model's face passing by either side of the nose, and intersecting the eyes and the mouth. Decide at which points these lines intersect the features: half-way, one-quarter into the forms… then, superimpose these lines on your drawing and if necessary readjust the placement of the eyes in the sketch, and notice if they are lined up over the nose and the mouth in the appropriate places.

Sketch lightly and interpret the features loosely without details.

Note the width of the mouth in relation to the width of the nose at the level of the nostrils. This can be calculated by closing one eye and sighting your pencil along this angle; touching the outer edge of the nose and the outer edge of the mouth on the left side then on the right. Transfer the angle your pencil assumes on to your drawing as a check on your width relationships. Draw the mouth as a banana-shaped form. We will draw it specifically later on. If time permits add any additional lines or creases which you see around the mouth. See Fig. 5–4.

Fig. 5–3

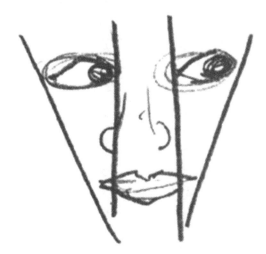

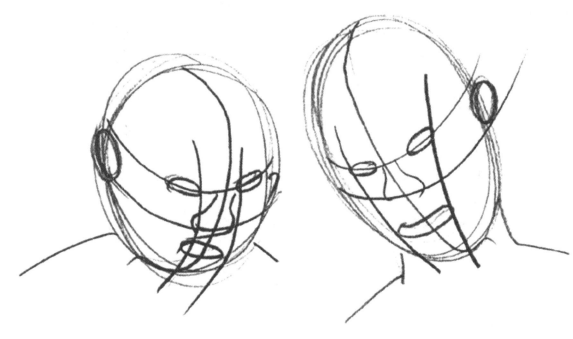

Fig. 5–4

EXERCISE 2
15 minutes

Use conté or graphite on cartridge paper.

Ask the model to take fifteen, 1-minute poses, changing the shape of her/his mouth in each, and periodically turning at 45 degree angles towards the left and right so the whole group benefits from frontal and profile views of the mouth.

Sketch only the mouth, putting 4 – 5 to a page. Pay attention to the specific outline, shape and thickness of the lips noticing how the upper and lower lips differ from one another. Suggest an open mouth by indicating the tongue, and teeth and, using the side of your chalk to shade the shape of the dark interior. Capture the essential forms quickly and exaggerate the expressions. If time permits add any creases or wrinkles which surround the mouth but ignore all other features. See Fig. 5–5.

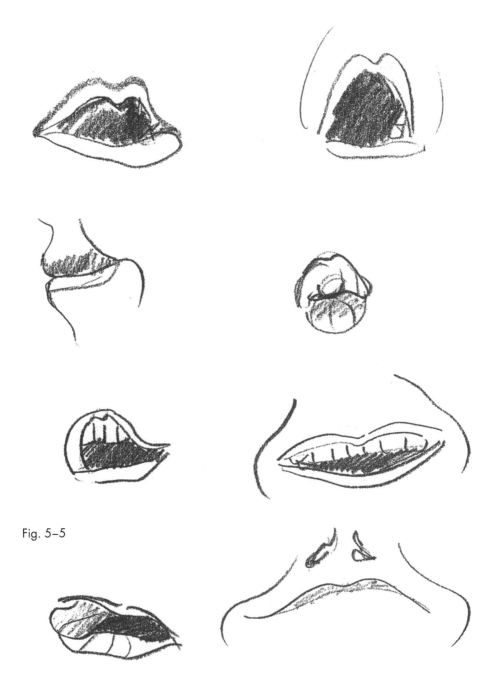

Fig. 5–5

Look at other participant's sketches.

BREAK
5 minutes

EXERCISE 3
20 minutes

GEOMETRIC HEAD AND DETAILED MOUTH

Use conté and graphite then a coloured crayon on cartridge paper. Have the model take a comfortable pose.

Part One – 10 minutes

Sketch the head, neck and shoulders as large geometric masses then subdivide them into smaller ones. (see Exercise 6, Chapter 2). Draw all the features generally including the mouth.

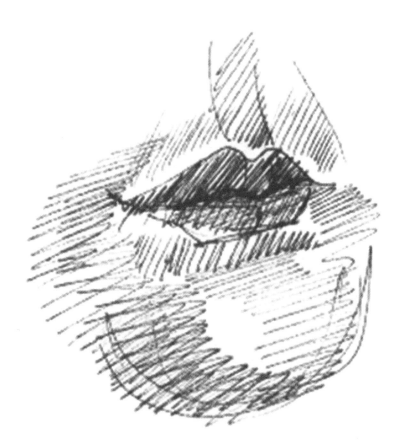

Fig. 5–6

Part Two – 10 minutes

With a coloured crayon superimpose a detailed mouth on top of the general one you just drew, using the parallel line technique of Exercise 1 to help you position the mouth accurately in relation to other features. Include any creases or wrinkles around the mouth, paying attention to their relationship with surrounding forms and negative spaces. If you see lines extending from the corners of the model's mouth going beyond the defined lips, draw them.

Notice the quality of the line in between the lips – is it uniform or varied ? Is the left side of the mouth the same as the right? Are the upper and lower lips the same thickness? Ask yourself these questions as you sketch the specific mouth on top of the generalized one.

Circulate and look at other drawings.

BREAK
5 minutes

EXERCISE 4
20 minutes

MEASURING THE FACE

Use conté or graphite on cartridge paper and a long pencil or stick (skewer) for measuring.

Part One – 10 minutes

... estimating proportions with your eye.

Take the first few minutes to lightly sketch in the head and main features, estimating proportions with your eye.

Part Two – 10 minutes

use your eye to measure first, then if something does not look 'right' check by measuring mechanically

Refer to the method of taking relative measurements in Exercise 4, Chapter 3 and measure some of the distances between facial features and negative spaces. Begin by choosing what appear to be equal or near equal distances, then refer to your sketch and check how accurate your estimates were.

... there are no absolute relationships, each face is different and needs to be discovered...

For example, suppose you drew the length of the nose from tip to bridge equal to the width of the mouth. If your eye estimate was correct and the two measurements are similar, then double check your accuracy on your sketch. To do this, place your pencil or straight edge on top of the nose you drew and with your thumb mark off its length on the tool. Transpose this length by shifting the tool (still marking the length) and laying it on top of the sketched mouth. Is it the same width? If not, adjust your drawing.

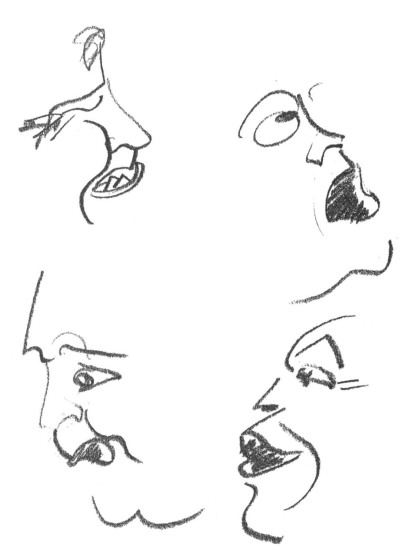

Fig. 5–7

This measuring technique is a double check. Use your eye to measure first, then if something does not look 'right' check by measuring mechanically. Measure some other distances such as: width of mouth and total width of both eyes (including the space between them), the vertical distance from the bottom of the eyelid to the bottom of the nose compared to the width of both nostrils, and the height of the chin with the width of one eye… Any distance, vertical, horizontal or diagonal can be measured and compared, but remember there are no absolute relationships. Each face is different and needs to be discovered; try not to make assumptions. Observe the specific individual and respect her/his uniqueness.

BREAK

5 minutes

Practice measuring items in the room.

People use body language and facial expression as a means of nonverbal communication and the portrait maker who wants to reflect feelings, attitudes and emotions in his/her drawings needs to pay careful attention to these messages. These expressions are a spontaneous reflection of an emotional state and happen quickly; some are subtle, as in a curious glance; others are intense, as in an expression of rage or hilarity.

Because expressions are momentary and fleeting, they present a particular challenge for the artist. Using an active, gestural line is helpful under these circumstances. Honoré Daumier and Toulouse-Lautrec were particularly adept at conveying facial expression in their drawings, and they did not hesitate to use exaggeration and distortion to communicate. Look at examples of their drawings.

The difference between an exaggerated portrait and a caricature can be confusing. A caricature is a specific type of drawing where the artist chooses to greatly exaggerate one distinctive feature of the subject. The result is unmistakable and often borders on the absurd, as in the caricatures of political cartoonists. Other features and elements are usually kept in scale.

An exaggerated drawing remains plausible because the artist draws attention to one or more features emphatically but maintains the harmonious proportions of the whole.

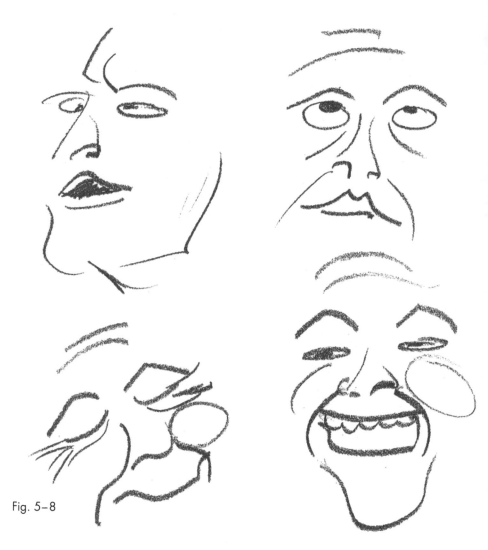

Fig. 5–8

EXERCISE 5
15 minutes

FACIAL EXPRESSIONS

Use compressed charcoal on cartridge paper.

*draw quickly and
urgently*

The model will determine the length of the poses depending upon
their strenuousness: the shortest to be about 20 seconds, the longest
60 seconds. Sit close to the model, preferably in front, and ask
her/his to point her/his face in different directions so everyone gets
changing views periodically.

... leave out all details that are not directly linked to the core of the expression... Essentials first and additional information only if you have the time.

You will be called upon to draw quickly and urgently so make sure your materials and paper are set up. Imagine that you are drawing Japanese or Harlequin masks and therefore features such as ears, hair, etc... can be omitted because they are not essential. The objective of this exercise is to move immediately to the essence of the facial expression and to describe it with as few marks as possible.

Because the model is determining the length of the poses, let us presume they are all short. Therefore, leave out all details that are not directly linked to the essence of the expression. For example, if the model is whistling, the pose might create movements in the mouth and eyebrows so quickly suggest the intervening nose and eyes, but emphasize the mouth and eyebrows. Or, if the model winks one eye, don't waste time by starting to draw the chin. Let your chalk glide swiftly through features that are not essential to the expression. Essentials first and additional information only if you have the time.

Look – react – draw Don't waste time drawing outlines – go for the center of the expression and add other elements if time permits.

Fig. 5–9
R. B. Kitaj
His New Freedom
1978

The resulting sketches should look like masks: forceful, expressive, and minimal. Think of each pose as a unique moment which demands a unique response. Students who do best at this exercise allow themselves to react emotionally and don't complicate the process by intellectualizing. Look – react – draw and work quite large, perhaps 2 – 3 faces per page so that your gestures are not restrained. Don't waste time drawing outlines – go for the center of the expression and add other elements if time permits. This exercise is not easy, but it is very rewarding. Be awake and alert and work with conscious urgency since you cannot predict the length of the poses. See Fig. 5–8.

BREAK
5 minutes

Organize your papers, look at the other participant's drawings.

Fig. 5–10

If you had difficulty with the last exercise and found yourself unable to let go and react, take stock of your situation. Are you physically ready to react to the model? Check your paper, easel, and other materials to be sure that the mechanical set-up is not impeding your actions. Some students find it helpful to sketch with their non-dominant hand, a change which may disorient you just enough to let you break through your inhibitions and react to the situation.

EXERCISE 6
15 minutes

Same as above. Have the model take vastly exaggerated poses (and try not to make her/him laugh!). In response work more quickly and more forcefully by pressing down harder on the chalk and making darker thicker lines and masses. Work urgently as you strive to capture the moment.

Walk around and look at sketches.

BREAK
5 minutes

EXERCISE 7
45 minutes

PHYSICAL PROXIMITY

Same materials.
Arrange easels or chairs in a large circle.

Your physical distance from the model is significant when drawing. The further away you are the easier it is to objectify the subject and remain apart from the emotionally charged action. This objectivity blocks your emotional responses and impairs your ability to empathize.

Ask the model to hold nine 5 minute expressive poses and to sustain eye contact with a student in each case. For example s/he might rest her/his chin on the drawing board, or peek around the easel at the student… (the model might want to sit on the floor, a stool or remain standing).

Once the model has chosen a 'victim' the rest of the group should be prepared to shift position. If the model's face is not visible the student being looked at becomes your model. Draw any facial expressions of interest in the room: the model or other students. When you are confronted by the staring model put your feelings into the drawing.

HOMEWORK ASSIGNMENT

Repeat the home assignment of Chapter 4, building up all facial elements studied thus far, and focusing your attention on the mouth. Find a lively public place where people are animated by talking, smoking and eating. Concentrate on capturing facial expressions and enjoy the challenge of working with urgency.

Fig. 5–11
Oskar Kokoschka
Portrait of a Gentleman
(Ivar von Lücken)
lithograph 1918

COMPOSITION

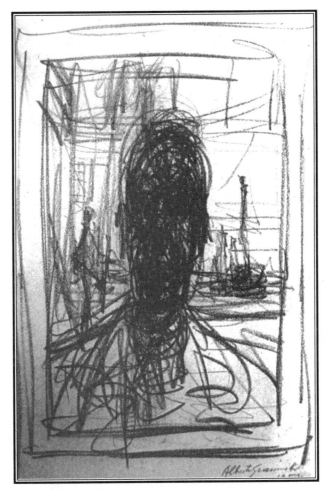

Fig. 6–1 Alberto Giacometti *Study* crayon 1952

Composition is the coherent organization of forms within a given area. There can be no drawing without composition. Good composition is the result of good thinking: some consideration of major geometric forms; the balancing of spaces and volumes, lights and darks, lines, textures, and colours… composition is based on the law of harmony, the fact that like seeks like. The repetition of lines, forms, tones, and colours is a compelling sign which the eye must follow. Repetition is psychologically pleasing. Contrast is used to emphasize, break up monotony by variation. – John Sloan

Composition reinforces the artist's intent using structure & design

For this chapter have the model bring 3 – 4 different hats or supply them yourself. Note that a hat changes the shape of the head, and account for this in your sketches.

The composition or design of an artwork refers to the arrangement of elements in relation to each other and the whole. Sometimes relationships are subtle; sometimes they are pronounced. The composition's function is to reinforce the artist's intent or concept by giving structure and design to the formal elements of the work.

The compositional elements which we are working with are: lines, masses (shapes) and negative spaces. Some of the criteria to consider when arranging these elements are: the rhythm, movement, and weight of forms and spaces, and the tensions or directional pulls and thrusts of lines. These considerations are as relevant to portraiture as they are to any other drawing themes.

Rhythm
can result from the patterns marks make on the surface of the paper, or the repetition of elements.

Movement
might refer to the way lines guide and direct our eyes around the drawing to where the artist wants us to look.

Tension
is a visual force which can pull the eye vertically, horizontally or diagonally or create vibrations between different forms.

Weight
might refer to the tendency of some forms and masses to appear heavy and grounded in contrast to others which appear light and floating.

Pictorial composition is a profound topic for the beginner, so we will limit our concerns to:

A. experimenting with diverse points of view.

B. consciously selecting one point of view which reinforces a statement we wish to make about the subject.

C. analyzing our choices in terms of dynamic visual effect.

For the following exercises you will need a viewer; either cut one out of cardboard or use a 35mm plastic photographic slide casing (empty). To begin, notice that the window of the viewer is rectangular. Two possible formats are suggested: holding it upright (vertically), or sideways (horizontally). This is your first compositional choice – do you want a long view or a wide view? We will experiment with both.

To practice using the viewer look through the window, keeping one eye closed, and move the frame around the room so that you have changing views of people and objects. Stop to examine a subject and advance or retreat the viewer by stretching or bending your arm. These movements alter the physical distance between you and your subject (recall Exercise 7 in Chapter 5), and can affect the emotional dynamic of the drawing. Remember that you stay in one place, and move the viewer around.

Move the viewer to the right or to the left of your subject and notice how the negative spaces rearrange and affect the integrity of the pose. For example, the visual effect of a model close-up and dead center might be confrontational, while a tiny model surrounded by an enormous amount of space might appear vulnerable.

Using a viewer helps you select the kind of universe you want in your drawing; you can eliminate or include whole elements or partially cut them off (cropping). Some artists use viewers, others visualize their compositions without them, but in either case a process of selection and elimination occurs.

Figs. 6–2

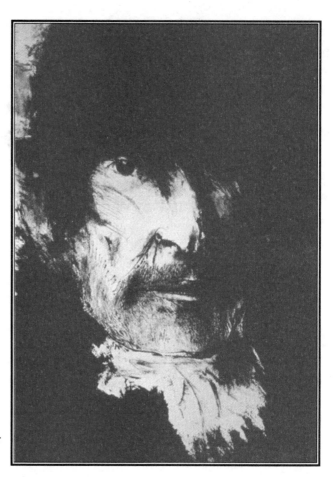

Fig. 6–3
Leonard Baskin
Babeuf
ink 1966

WARM-UP
5 minutes

Use conté or graphite on cartridge paper.

With your eyes closed and a relaxed grip on the drawing tool, sketch one continuous random line. Let this line wander off the page and back on to it with a flowing, uninterrupted gesture. For example, if the line drifts off the top of the page let your hand drop to the side of page and re enter. Develop a physical sensation of the dimensions of your surface, anticipating when your hand approaches the boundaries of the page. Be conscious of staying on the page or moving off. This will free you from having to watch yourself draw and permit you to focus your energy on your subject. Remember that your drawing arena is your whole surface area, and that the movement of lines can continue into space. Occupy your space but don't limit yourself unnecessarily.

EXERCISE 1
40 minutes

DIFFERENT POINTS OF VIEW

Same materials. Have the model sit in a comfortable pose.
This is a four part exercise, requiring 4 large rectangles to be drawn on your page, 2 vertical and 2 horizontal. Their proportions should equal those of your viewer. See Fig. 6–4.

Fig. 6–4

Draw large shapes only, omit details.

Part One – 10 minutes

Close one eye, look at the model through the viewer, and select an arrangement of forms and negative spaces that leaves plenty of space around the model's head, neck and shoulders. Notice if you are holding your viewer vertically or horizontally and begin to sketch into a rectangle of the same format. Is your distribution of masses and negative spaces and their relationship to the four boundaries in the sketch the same as those in the viewer? Draw large shapes only, omit details.

Some students hold the viewer in front of their eye the whole 5 minutes, others look through it then sketch from memory, repositioning it from time to time. Either method becomes easy with practice.

Fig. 6–5
Andrew Wyeth
Study for Karl
pencil 1948

Part Two – 10 minutes

If the viewer was held vertically in part one, place it horizontally this time (or vice-versa). Advance the viewer so it frames the model's head, neck and shoulders and places the model in a different part of the

viewer than the previous composition; as a consequence the negative spaces around the model will be rearranged. Choose a rectangle of appropriate format and sketch in this second viewpoint. Work swiftly placing the principal masses and ignoring all details. Be particularly aware of how shapes and masses stay inside or are cropped and move out of the picture frame.

Advance the viewer so it frames the model's head, neck and shoulders and places the model in a different part of the viewer than the previous composition; as a consequence the negative spaces around the model will be rearranged

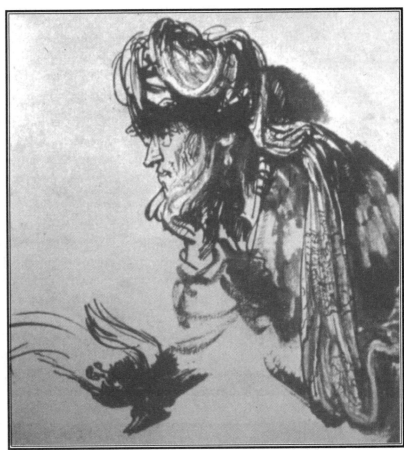

Fig. 6–6
Rembrandt
Nebuchadrezzar
ink circa 1630

Part Three – 10 minutes

Advance the viewer so that only part of the model's head and neck are in the frame, and make your selection according to which lines and curves are most interesting to you. Proceed to transfer your view onto the paper. Remember to actively decide if you want a vertical or horizontal frame; your choice is directed by your visual response to what you are looking at – if it looks pleasing – go with it.

Part Four – 10 minutes

For the final viewpoint, advance the viewer until you have a close-up of the model's face. Pay particular attention to the possible ways in which you can crop the face; can the pose be cropped in a meaningful way without looking awkward? Transfer this view into the remaining rectangle on your page.

Examine the four different arrangements, considering their merits and weaknesses. Choose the one you like best and ask yourself what it is you like: does it feel harmonious? Dynamic? Is it unusual? Indicate your choice with an * and take a break of 5 minutes to observe and discuss other participant's choices.

... details might be important but the integrity of the whole is essential.

Some students have difficulty in choosing their preferred composition. If you cannot choose your favorite, proceed by elimination: Is one of them boring? Static? Conventional? Confusing?

Strong compositions do not happen by magic. They are consciously designed by the artist. Keeping this in mind, avoid repetitive devices and conventional habits such as always placing the subject in the middle of the frame in order to create 'balance'. We might consider this a 'bull's eye' approach to design; imagine all of your furniture arranged in the middle of the living room. Is it balanced? Perhaps, but balance does not depend upon symmetry. It results from a harmonious interaction of elements. An over dependence upon symmetrical arrangements often produces visually static compositions. A habitual device is any visual effect that an artist keeps repeating because it was previously effective. Instead of playing it safe, try to invent new solutions for new drawing situations.

When studying a specific element in detail or doing a fast sketch, it is understood that compositional considerations are not a priority. But, embarking upon a formal drawing and developing details immediately, without any consideration of the general layout and placement of large masses, is an oversight – details might be important but the integrity of the whole is essential. When drawing and painting, artists frequently rebound between awareness of the specific to the general, the parts and the whole. A successful composition values individual parts, but strives to reinforce the harmony of the whole.

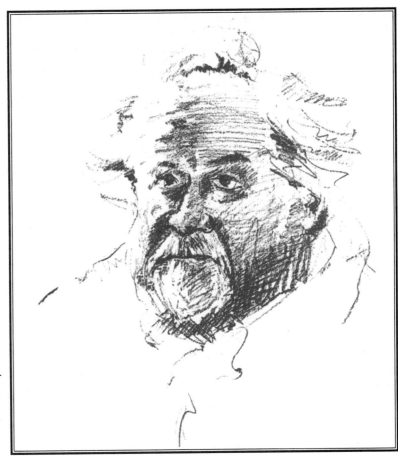

Fig. 6–7
Joanna Nash
*Sketch of
Jean-Claude Labrecque*
pencil 1992

EXERCISE 2
20 minutes

Same materials. Have the model take a comfortable pose wearing a hat (this pose will be repeated in the next exercise).

Once again look at the model through the viewer. Plan and sketch 4 possible compositions communicating 4 different physical spaces around your subject. Take 5 minutes to do each and remember to stand in one place and let the viewer move for you. After the break we will develop one of the arrangements which we will call a 'cartoon' (not to be confused with newspaper comics, but rather, as a model or plan).

BREAK
10 minutes

Circulate and discuss the choices.

EXERCISE 3
20 minutes

TRANSPOSING THE CARTOON TO A DIFFERENT FORMAT

Use charcoal on cartridge paper.
Have the model resume the previous pose.

There are a number of precise methods using grids for transposing a cartoon to a larger format; we will use an approximation that is sufficient for our purposes. Notice whether the cartoon is vertical or horizontal and divide it into 4 sections by drawing intersecting crossed lines down the middle. Then, detach it from your easel and place it on the floor where you can see it. Draw a corresponding rectangular format on a clean sheet of paper, but make this rectangle quite large, occupying at least 3/4 of the new sheet, and lightly but visibly divide it into 4 sections like the cartoon. Study the cartoon – where does the central intersection of lines divide your subject? How are the masses distributed amongst the 4 sections? Is anything cropped? Now, lightly sketch the arrangements of masses and negative spaces into the corresponding quarters of the new rectangle; approximate and draw freely. Life is short and we want a general layout of the initial cartoon, not a technical drawing. Press lightly with charcoal; erase and modify as you transpose the composition. It is helpful to periodically look at the live model through your viewer, although the original cartoon generally provides sufficient information for the layout. Draw large masses – avoid details.

> *… approximate and draw freely… Draw large masses – avoid details.*

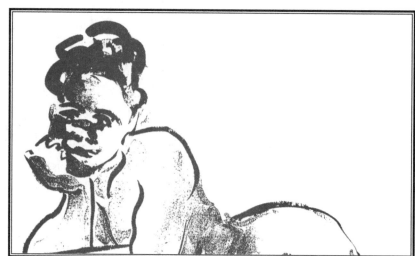

Fig. 6–8
Joanna Nash
Study of Catherine
ink & brush 1990

BREAK

5 minutes

Look at other participant's sketches.

EXERCISE 4

60 minutes

Break halfway through. Conté on cartridge paper.

Have the model take a comfortable pose wearing a different hat.

For the first 10 minutes repeat the process of Exercises 2 and 3, sketching 4 small compositional arrangements of the subject. Sketch quickly, leaving out details, and concentrate on the placement of the principal elements. For each individual viewpoint determine a focus by asking yourself what it is you want to respond to, and what your eye finds appealing. To take a risk in composition means to invent something that suits the situation rather than using a habitual device. Allow the subject to evoke an emotional response in you and develop this into a design strategy which enhances and reinforces the initial feeling.

For example, if the line of the neck, or the shape of the hat, or the expression of the eyes attracts your attention, it could be enhanced by one or more of the following strategies:

A. a prominent placement of this feature

B. using directional lines or thrusts to direct the eye toward it

C. giving it weight or lightness in relation to other components

D. juxtaposing it dynamically against another elements

E. repeating the qualities of this element in other elements
 (e.g. an angular neck reinforced by other lines interpreted in an angular fashion…)

F. contrasting the dominant feature with other qualities
 (e.g. an angular neck contrasted by curved, organic shapes…)

Any format is acceptable in a work of art if it enhances the artist's vision and intent.

Place the cartoon on the floor where you can glance at it, but this time do not transpose the cartoon – just recall the feeling of the chosen design and develop the sketch free hand in the remaining time on a larger sheet of paper. Any format is acceptable in a work of art if it enhances the artist's vision and intent. Cut different viewer formats out of cardboard, e.g. very long or very wide, triangular, oval etc… Experiment with them; choose varying formats for visual reasons, not just to be different. A little masking tape applied to the plastic slide viewer can alter the proportions – but remember to adjust the drawing format accordingly.

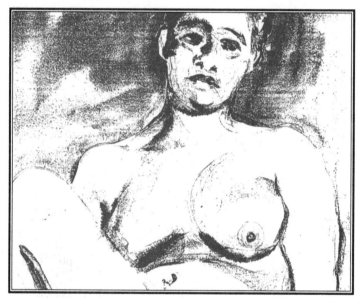

Fig. 6–9
Joanna Nash
Study of a Woman
watercolour 1989

On cartridge paper, any drawing material you like.

HOMEWORK ASSIGNMENT
30 minutes or longer

Do one of the following:

A. a self-portrait showing elements of the room you are in.

B. draw a friend or house pet in its favorite chair surrounded by some objects.

C. take one of your little sketchbook drawings and do a larger drawing, elaborating or inventing a room or environment to surround the person or people in the sketch.

LIGHT AND DARK

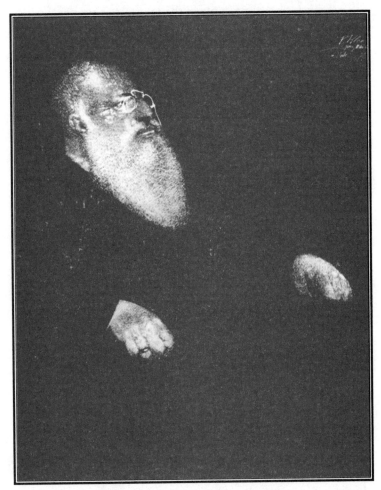

Fig. 7–1 Paul Klee *Portrait of My Father* verre églomisé 1906

Most of the earliest forms of drawing known to us in history… are largely in the nature of outline drawings… a line seems a poor thing from the visual point of view: as the boundaries (of masses) are not always clearly defined, but are continually merging into the surrounding mass and losing themselves, to be caught up again later on and defined once more. – Harold Speed

Review the definitions in Chapter 1 and then study these drawings: Fig. 7–2 and Fig. 7–3 They are examples of a linear and a tonal style, each one exhibiting different qualities and effects. Fig. 7–2 is a linear drawing with shapes circumscribed by line. Although volume is suggested, there is little sensation of depth and weight. Such is the quality of this minimal drawing: airy with a satisfying potential for lightness and simplicity.

Fig. 7–2
Henri Matisse
Portrait of Mme. L.D.
pen & ink 1937

Fig. 7–3 is a tonal drawing where the artist shaded with gradations of white and black and did not feel the desire to represent outer edges by lines. As a result, light and dark shapes merge and outlines disappear giving a hazy effect to the edges. The visual effect of this tonal treatment is softness, graininess and density. In the first few chapters of this book we used line as a sufficient means of interpreting the shapes and proportions of the human head. Now we are going to examine tone and the development of volume.

Fig. 7–3
George Seurat
Portrait of Father
black conté circa 1880

HOMEWORK ASSIGNMENT

Place a white egg on a dark surface, and control the lighting so that it falls on the subject from one direction only. Look closely at the edge of the egg where it meets the dark background. Two masses lie side by side – a light tone meeting a dark tone. It is the meeting point of these contrasting tones that makes the edge of the egg visible. There is no actual outline circumscribing the egg; objects are solid masses coming into contact with other solid masses. The outline is a device which we can impose to give a feeling of tangible reality to an object.

Now, place the egg on a white surface (piece of paper or cloth), and examine the edge of the egg. Depending upon the strength of lighting hitting it, the form of the egg may contrast minimally or maximally with the negative space around it. The white object on a white surface and the adjacent shadows can be interpreted in subtle gradations of gray.

Fig. 7–4 M.C. Escher *Three Spheres 11* lithograph 1946

... objects are solid masses coming into contact with other solid masses. The outline is a device which we can impose to give a feeling of tangible reality to an object.

WARM UP
10 minutes

Use one of the varied dry drawing materials: graphite (pencil and block), conté (different colours), regular charcoal, compressed charcoal, wax crayon, and soft and hard erasers (consider these drawing tools, not correctors!)

Work in masses not in line...

Review the warm-up exercise at the beginning of Chapter 3 when you drew lines and tested the tonal range of your different chalks. This time, using a variety of different hand motions, practice ways of shading, that is, ways of depositing gray matter on the page. Work in masses, not in line, and press: lightly, harder; smudge with fingers, paper stumps, or cloth, blend edges, erase white marks into the tonal areas with the two different kinds of erasers. Play!

Our aim is to create numerous tonal effects and work with masses of tone not line.

Fill a page with tonal textures using all of the materials. As you work ask yourself the following questions: How light or dark can each material be applied? What is its full tonal range? Can you draw with the eraser? Do the materials mix, or superimpose easily? Are they all compatible? Can the coloured conté be applied over graphite and vice versa? Fill the page with answers to these questions. Give yourself the time to play with each new material; this is a stage of experimentation in which you can discover important visual effects. Build up layers of colour; erase and reveal light areas in dark masses, etc... Our aim is to create numerous tonal effects and work with masses of tone, not line.

EXERCISE 1
20 minutes

Use charcoal or conté on cartridge paper.

... remember to develop masses not lines.

Arrange the easels and chairs on either side of the model, so that everyone has a side view of one ear. Ask the model to arrange her/his hair so that the ears are fully exposed. In this exercise we are going to examine the anatomy of the ear and then shade in masses without using line. The ear can be a distracting part of the portrait if it is badly drawn; this shows that the artist has not sufficiently familiarized him or herself with anatomy.

Move your hand and curve your shading to conform to the curves of the ear.

Before you begin to sketch, observe the model and ask yourself the following questions: which is the lightest part(s) of the ear? The darkest? How many different tonal values do I see? three, five, more? Is the dark gray of graphite sufficiently dark or would black chalk be more effective to extend the lower end of the scale?

Sketch a large ear 15 cm – 20 cm (6" – 8") so you have enough room to develop the forms. Remember to develop masses, not lines. Interpret whole individual masses, noticing how they relate to neighboring masses in shape and proportion, and repeat some of the shading techniques you invented in the warm up: smudge on colour, spread it, superimpose, lift off highlights with erasers, etc… Compare values constantly; articulating to yourself: "dark, lighter, lighter still, very dark" etc… and respond to these variations with your drawing materials and manual pressure.

Observe the curves of the ear and shade these curving masses to emphasize their roundess; the effect of volume is enhanced by contrasts of light and dark masses. Keep in mind that lights have a tendency to advance while darks appear to recede as you suggest the depth and volumes of the ear. While shading the landscape of the ear be attentive to the motions of your hand: how are you applying colour on curved surfaces? Recall the surface of the egg and how lines conformed to the curve, and echoed the movement of the form. Move your hand and curve your shading to conform to the curves of the ear. Step back periodically to look at your drawing, then continue.

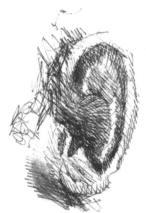

Figs. 7–5

BREAK
5 minutes

Examine the sketches of other participants.

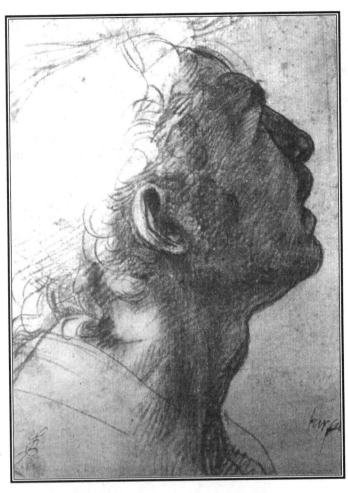

Fig. 7–6
Andrea del Sarto
Study
circa 1500

EXERCISE 2
20 minutes

Use compressed charcoal on cartridge paper and one or two soft charcoal erasers. For the following exercise you need a spotlight with a 75–125 watt bulb, a reflector lamp on a tripod, and sufficient length of extension cord. Our objective is to expose light masses on darkened paper using erasers.

Prepare your paper by covering the entire surface with a layer of black compressed charcoal, holding it on its side and rubbing vigorously using moderate pressure. After one layer is applied rub it in with a cloth, then repeat with a second layer until you have a smooth uniform gray-black surface. Your drawing tool is the charcoal eraser, so warm it up in your palm.

Start at the tip of the nose and work out in all directions slowly

... your edges are formed by contrasting tones, not outlines.

Seat the model in a dark area of the room and turn off most of the overhead lights. Place the spot light at a 45 degree angle, to the front of the model and one or two feet above his/her head, making sure the light is not shining in his/her eyes. Our aim is dramatic lighting, so arrange the spot to create strong highlights and deep shadows on the models face, neck and shoulders. Arrange the easels and chairs towards the dark side of the model (the opposite side of the spot-light), making two rows of easels and chairs if necessary. From this angle you should see both light and shadows on the model.

As you are warming up the charcoal eraser in your hand take the time to look at the model and notice how the light falls on his/her features. We are looking for light masses; these are the ones you will "erase". Start at the tip of the nose and work out in all directions slowly (recall Exercise 7, Chapter 3). Identify one light mass at a time: erase its form and compare its tonal value with the tonal value of its neighboring forms. Erase basic forms as masses not as lines, your edges are formed by contrasting tones, not outlines. If you get lost return to the tip of the nose then venture out again. See Fig 7–7.

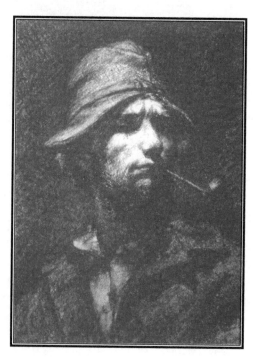

Fig. 7–7
Gustave Courbet
Self-portait
charcoal circa 1850

The warmed up eraser can be molded into different shapes as you work and will pick up the black compressed charcoal on the paper. When it gets too black to absorb more colour, knead it to expose a clean area and continue. Erase the lightest areas as white as you can, leaving degrees of gray where there is less light. If you have erased too much, smudge some dark colour into the area and rework it.

When two contrasting tonal masses are side by side the edges of shapes are clearly defined. Soft, fusing edges occur when similar tonal values are side by side. Periodically step back and glance at your sketch and at the model to keep you in touch with the overall effect of the lighting. After being immersed in specifics step back and consider the whole.

BREAK
5 minutes

EXERCISE 3
30 minutes

Compressed charcoal on cartridge, or manila paper. Use your viewer.

To make the lighting less dramatic than the last pose ask the model to take a comfortable pose further from the spotlight, and have him/her wear a large brimmed hat to cast shadows on his/her face.

Spend 10 minutes planning 4 small tonal compositions; looking through the viewer search out different distributions of light and dark masses. Note where the tonal masses are distributed in the frame and use the flat side of your chalk to shade in patches of light and dark. Do not sketch with line. The pattern of light and dark masses effect: balance, weight, movement and thrust by their placement in relationship to each other. Select 4 different arrangements of masses, each one having a different pattern of light and dark distributions. Think of your eye as being capable of linking and following the light masses through the drawing. This is also true of the darks – their pattern sets up pathways for the eye to follow.

Work without lines

In as brief and uncomplicated a manner as possible, transpose your chosen composition to a larger format of cartridge, manila, or mayfair paper. Consider whether you are working with a vertical or horizontal format, and how the forms interact with the boundaries of the frame.

Spend the next 20 minutes developing the light and dark contrasts in this sketch. Work without lines, making large loosely rendered strokes with the flat side of your drawing tool. When you are drawing tonally remember that you can lay down matter, lift it off, superimpose, rub, blend, etc... Do not hesitate to be vigorous in your manipulations. Let yourself go, trust your eye, and your materials. If you see something that appears linear, see if it is the meeting of two contrasting masses or if it really is a distinct line. Continue to work tonally. See Fig. 7–8.

BREAK

5 minutes

Walk around and look at other sketches.

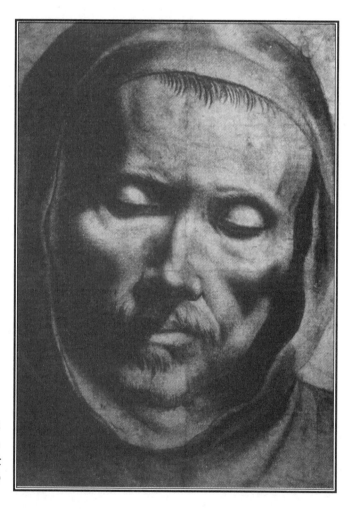

Fig. 7–8
Francisco de Zubaran
A Monk
charcoal circa 1600

EXERCISE 4
30 minutes

Middle gray paper with black and white conté.

Arrange the easels in a semi-circle around the model who has her/his back resting against a wall. Shut off overhead lights and angle the spotlight so that interesting lights and darks appear on the model and a long shadow is cast on the wall to one side of his/her head.

Close one eye. Sight your viewer on the subject and compose an arrangement that centers the shadow. Include the model or part of the model, but not in the center of the frame. Hold the viewer in your non-drawing hand and keep the view until the main elements have been sketched onto your large format.

Note the distribution of light and dark masses on the model and the wall. Where is the strongest degree of contrast? What is lightest, darkest, middle tone? Establish which of the masses is closest to the spotlight, which are further away, and how this effects the intensity of light. Examine the transition of the dark side of the model's face into the wall shadow. Is it smooth? Abrupt? Look at the edges of the cast shadow – is it consistently defined all the way around? What degree of definition, or fuzziness exists? As you sketch ask yourself similar questions, it helps you think critically about tonal values.

Thus far you have been working on white paper, and in your eraser drawing (Exercise 2) on blackened paper; in both cases you have started your drawing from an extreme of light or dark. A different approach is to draw on middle gray paper; let it represent your middle tone. White and black conté are used to expand the tonal range in both directions towards white and black.

Begin by studying the lighting on your subject and search out the middle values which can be represented by the gray of your paper. In this case the gray paper might remain untouched or only slightly lightened or darkened where you see middle value. When you see darks use degrees of black conté, and where you want to communicate different gradations of light apply thin or heavy amounts of white conté. The quantity of gray paper you leave untouched by black or white chalk is a personal choice. Experiment. See Fig. 7–9.

10 minutes

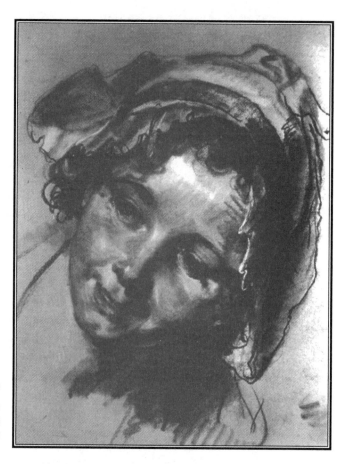

Fig. 7–9
Jean Baptiste Greuze
Study of a Woman
conté crayon circa 1790

EXERCISE 5
30 – 40 minutes

Same materials as previous exercise, and add sanguine or brown conté.

Seat the model .6 m – .9 m (2 – 3 feet) away from the wall, and place the spotlight behind her/him, directing light onto the wall. During the day the model could be placed in front of a sunny window. Our objective is to create back-lighting, with the model's front obscured in shadow.

Both deep shadow and strong light obscure details, so focus on large tonal masses. When looking for patterns of light and dark masses it is helpful to squint your eyes half shut, this also serves to eliminate distracting details. Select a composition with or without the viewer, and consider where you want to position the dark mass of the model in contrast to the light background. Is there an aura of reflected light around the model? If so, indicate it.

In this drawing attempt to create a dramatic atmosphere; let yourself respond to the mood of the pose. As you develop your sketch step back periodically, glance at your overall sketch and back to the model, then resume drawing. Keep in touch with the overall; try not to get caught up in details. Consider the amount of gray paper you leave untouched, and experiment a bit differently than in the last exercise, leaving more or less exposed paper. Use the coloured conté as a middle value tone like the gray paper. It can be used to add interest to the middle values; use it as a tone rather than as a colour. Distribute it where you see middle values.

For inspiration study examples of tonal drawings by the French painter Seurat.

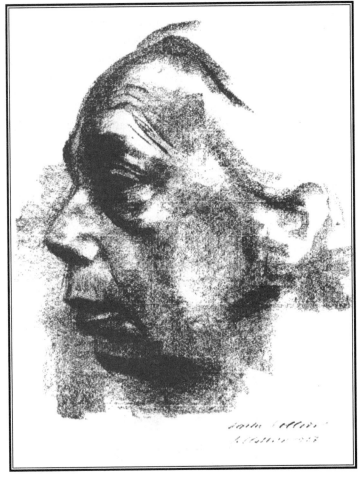

Fig. 7–10
Kâthe Kollwitz
Self-portait
lithograph 1927

HOMEWORK ASSIGNMENT
30 minutes or longer

SELF PORTRAIT DONE IN THE EVENING

Any materials.

Sit facing a large, dark window and experiment with the degree of light in the room. Your objective is to see your dark form and other objects in the room reflected in the window. Spend a couple of minutes looking at the overall arrangement of masses, then begin a tonal drawing.

Be selective and eliminate all distracting details, including only those essential to the scene. Do not force precision; draw what you see, or what you want to see, not what you think you should be seeing. Dark forms tend to push back as light forms pull forward. If forms disappear into obscurity, follow them into the darks; if a contrast jumps forward, emphasize it. Periodically step back and consider the overall distribution of light and dark masses, and how these masses form patterns which lead your eye around the drawing.

To change the overall mood and effect of your drawing you can alter the tonal range. For example, if you feel the lighting is too harsh and contrasted you can soften it by using closely related, subtle middle tones. If your subject appears too middle gray, you can exaggerate the contrasts to enhance the drama. With time and practice tonal values will become more understandable, and your drawing experiences with them will provide a strong basis for future colour work.

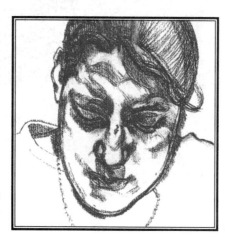

Fig. 7–11
Lucien Freud
Girl with Necklace
charcoal 1980

MOOD AND CONTEXT

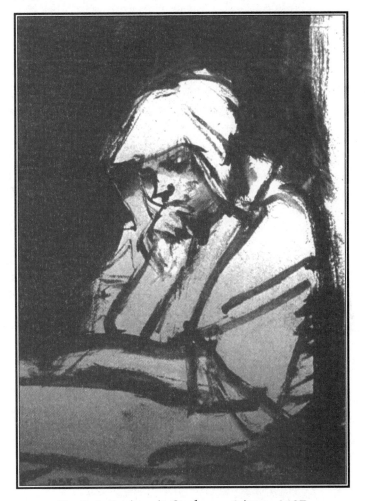

Fig. 8–1 Rembrandt *Study* pen & bistre 1627

It isn't what you see, but what you feel, that will make your work interesting.
You can look at a thing and see it but that's nothing. You can look at something
which may give you an emotion. That's feeling! – William Morris Hunt

For the sake of simplicity, in preceding chapters we have examined the model in isolation. But, in life, most people exist in relation to other people, things and places. A context can be a physical place or environment which is observed, imagined or remembered. It can be descriptive and explain something about the subject, or simply evoke a mood or atmosphere.

WARM-UP
10 minutes

Repeat the texture exercise of the last chapter. Add as many interesting linear marks as you can: on top of, underneath, and next to tonal masses. Your visual vocabulary now includes: lines, marks, and blended or textured tonal masses.

Hire a relaxed model who feels comfortable posing with props such as: patterned cloth, ribbons, balloons, hats, scarves, crepe paper streamers, fans, and other still life objects (see Exercises 2 and 3). A table and some of these props will be required after Exercise 1.

EXERCISE 1
30 minutes

Use any dry materials on cartridge paper and your viewer.

Part One – 5 minutes

Have the model move around the room until s/he finds a spot in relation to a wall, door, window, screen, room divider, coat rack, easel, or any large object. Place yourself to see both the model and the surrounding context through the viewer, and select a view which enlarges the model's head so that it assumes greater importance than the context. Focus on the model, but include elements of the context in your small cartoon (do a small sketch as in our chapter on composition).

...diminish the importance of the model.

Part Two – 5 minutes

Stay in the same place but move the viewer to select a different arrangement. This time emphasize the context, and choose ways to diminish the importance of the model.

Fig. 8–2
Andrew Wyeth
Study for Groundhog Day
pencil 1959

Part Three – 20 minutes

Any materials.

Develop your second composition. Begin by quickly establishing the main division of space, then put your energy into the development of the sketch. Work around the model, focusing your intention on the development of the context. Include the model incidentally, as if s/he just happens to be in the setting. See Fig. 8–2.

5 minutes

Circulate and look at other sketches.

EXERCISE 2
25 minutes

Any materials.

Pose the model in front of a textured background such as wood, brick, or patterned fabric. A texture can also be imagined or found in photographs, books or magazines. In this drawing give adequate importance to the treatment of the background. Begin with the general placement of the model, but do not develop the model – only develop the background working in towards the model's contours. This will leave the model as a white silhouette on the page. Once the background texture has been well established, begin to develop the tonal masses of the model. Pay particular attention to the way the tones of the background texture and those of the model fuse. Do not leave a 'no man's land' white aura around the model; connect the form of the model and the background. Our goal is to incorporate the model into a textured context. See Fig. 8–3.

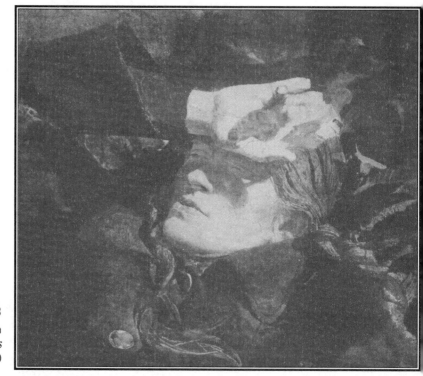

Fig. 8–3
Andrew Wyeth
Helga Series
aquarelle 1950

10 minutes

Props need to be set up for the next pose.

Do not distinguish between model and setting. The model is part of the setting; integrate the subject into the context.

Our objective is to physically immerse the model amongst the props to create a confusion of elements and to devalue her/his importance. As a result, the model becomes part of the overall ambiance;he/she blends into the pattern of elements. Without undue importance s/he remains part of the whole. Have the model pose in front of a wall, screen, cork board, or cloth draped solidly over two easels onto which lightweight objects can be pinned. Take pieces of fabric, scarves, streamers, tape, balloons, string, wool, rope, etc… and attach them partly to the model and partly to the backdrop. We want the objects to flow from the cloth to the model, visually linking the two. Partially drape a veil, light scarf or hat over the model's head to obscure some of her/his features. Using a spotlight is optional.

EXERCISE 3
30 minutes

Any material and the viewer. Frontal view or 45 degrees to left or right.

Move your viewer around, examining different designs which incorporate the model into the setting. Select one arrangement and start your drawing immediately, without a small compositional sketch but maintaining the compositional idea. Do not distinguish between model and setting. The model is part of the setting; integrate the subject into the context. Sketch tonally, incorporating lines, marks and textures.

BREAK
5 minutes

Walk around and examine other sketches.

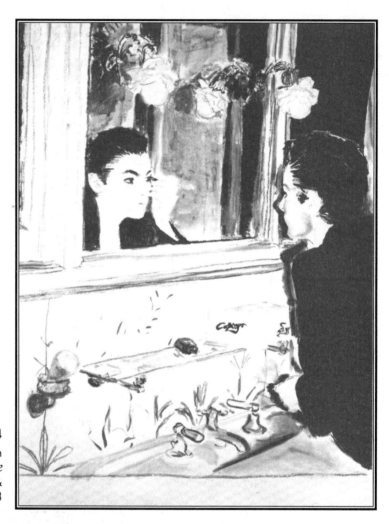

Fig. 8–4
Bill Sullivan
Brunette
oil crayon &
coloured pencil 1978

EXERCISE 4
30 minutes

THE MODEL AS A STILL LIFE

Any materials.

Have the model sit comfortably on the floor, a low stool or on a chair; we want the model's head to be at the same height as objects on the table. Assemble still life objects such as: bottles, baskets, balloons, fruit, toys, plants, flowers, boots, hats, styrofoam wig forms… etc. Arrange them around the model's head on the table. Your model might want to support or rest her/his face on her/his arms. Once again we want to

merge the model into a collection of inanimate objects. The spotlight can be directed on the still-life but not specifically at the head; direct general light on the whole set up.

Develop a drawing with an empty middle. That is to say move your viewer about until you have a negative space in the middle of the frame with objects (including the model's head) arranged around it. As you work, let your attention flow from the model's head to the other objects. Focus on all the objects and treat them with equal importance.

BREAK
5 minutes

Look at the others' drawings.

EXERCISE 5
30 minutes

White, orange and black conté on gray paper.

Ask the model to wear a costume or makeup that decorates his/her head and upper torso, and pose comfortably against a simply arranged background. Then, observe your model and imagine him/her in a landscape or setting that has some relationship to the costume or mood of the decoration, or look about the room for objects, shapes, or textures that you find appealing and transpose them visually into your composition. Arrange your design to give an important placement to the model. Use a spotlight and develop the drawing with any materials that appeal to you. See Fig. 8–5.

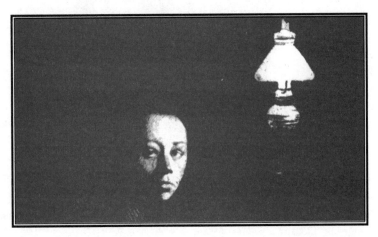

Fig. 8–5
Kâthe Kollwitz
Self Portrait at Table
etching & aquatint 1893

HOMEWORK ASSIGNMENT

30 minutes to 3 hours

Any materials.

Choose a sketch from any previous exercise which does not have a developed background. By working directly on the original drawing and adding forms or textures you will develop a context around it. You could add imaginary elements or use other visual resources such as images from illustrations, organic textures or rubbings.

A rubbing is a way of transferring the texture of certain objects onto a piece of paper. Place a piece of sketch paper on top of wood grain, a metal grill, a textured shoe sole, a tombstone surface, a silver dollar, mosquito netting, a sieve etc… With conté or compressed charcoal, rub on the paper over the textured surface and see the texture appear. Experiment with different textures before applying your sketch onto a surface and rubbing.

Add your background, adapting and changing the original sketch to accommodate the additional elements.

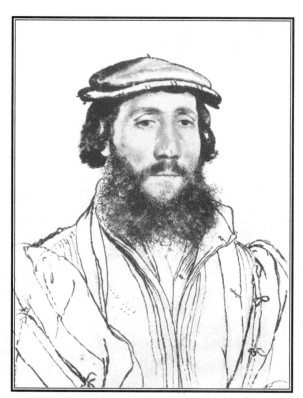

Fig. 8–6
Hans Holbein the Younger
Unknown Man
chalk & pen circa 1500

WET MEDIA

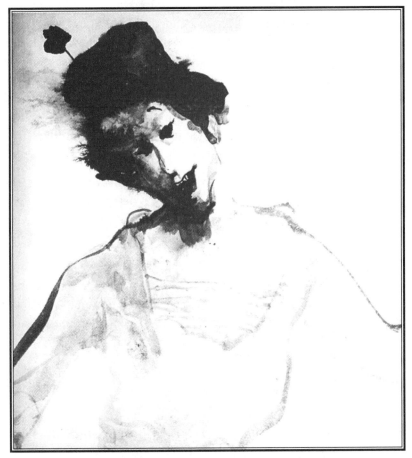

Fig. 9-1 John Gould *Performance Study of BIP* watercolour

Spontaneity and freshness are valued qualities in drawing. Essentially these lie in the draftsman's conception and performance; it seems, however, that the brush has a propensity for spontaneity and therefore will frequently encourage a draftsman toward a freer, more direct response to drawing... We know that each tool, each medium has its own voice. Assessment of the material means should come from direct contact with them, using a particular medium in connection with visual problems and seeing where it leads. The materials themselves will have a disposition or inclination – we must find our own relation to that natural proclivity. – Hill

Thus far we have worked with dry media in the form of chalks and pencils, the materials most commonly associated with drawing. Wet media such as inks and water-based paints, however, are also traditional graphic materials. Ink is a liquid that resembles a dye in that the pigment particles are fully dissolved in the liquid, unlike paint where pigment particles are suspended in a medium. Dried ink can be water soluble, meaning it can be washed away with water after dry, or waterproof – a surface which can withstand washes of water after it has dried. This is not to be confused with light fastness which describes the degree to which the ink is permanent when exposed to light. The light fastness or colourfastness of ink and paints is usually indicated on the packaging, and is reflected in the price of the product. Lightfast ink can be water-soluble or waterproof.

Traditional pens were made from feather quills and bamboo or wooden reeds. Later, metal pens came into being. In all cases the nibs (feather, reed or metal) were shaped to a point or square form with a vertical slit cut up the middle to hold liquid (see materials list in Chapter 1).

Ink can be applied with a pen, a brush or less conventional tools. When ink is used in undiluted consistency it gives a dark saturated mark; when it is diluted to varying degrees it becomes light and transparent. A smooth layer of ink applied by brush is commonly called a wash and can be combined with linear pen marks.

Absorbent, non-absorbent, smooth, or textured papers will all affect the handling and look of ink. See Fig. 9–2. This is an example of a linear drawing executed with pen and ink.

In Fig. 9–1 diluted ink was washed on by brush in combination with pen lines. The contrast of wash and line is appealing.

Fig. 9–4 is an example of an ink wash by Leonard Baskin. The ink is largely undiluted and appears dense and dark. The minimal amount of exposed white paper gives an intense, dramatic quality to the drawing.

Examples of traditional ink drawings are often brown (bistre or sepia ink); today, lightfast inks are available in many different colours.

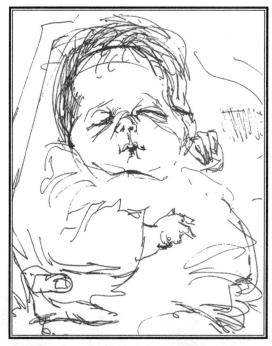

Fig. 9–2
John Gould
Maria Gould
pen 1959

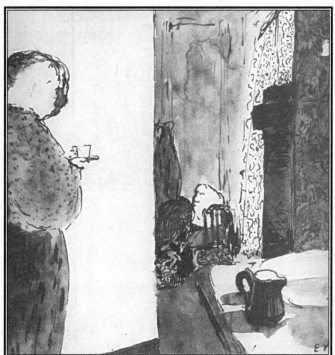

Fig. 9–3
Edouard Vuillard
Mme Vuillard at Home
pen & ink & watercolour
1894

EXERCISE 1

Gather the ink, pens, brushes and miscellaneous items listed in the materials section in Chapter 1. Work flat on a table and use Mayfair and Manila paper. Practice on both sides of the sheets.

MARKS

Dip your pen, sharpened twig, feather quill etc… into the ink bottle and tap off any drips. If there is a vertical slit cut into your nib, sufficient ink will be trapped. Make a few marks on the paper to see how much ink your pen can carry, and how different pressures on the nib affect the line. If you have nibs of various thickness try them all. If you have feathers (fluffy end), sticks, combs, cloth etc… dip them into the ink and drag them across the surface; any tool that can be dipped into ink can be used to create marks.

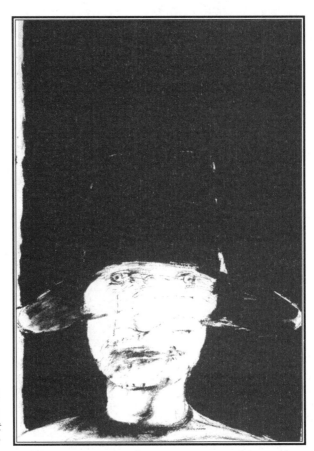

Fig. 9–4
Leonard Baskin
Lone Artist
ink 1969

WASHES

Once your marks and lines are dry, take out your soft and hard brushes, sponges and cloth. Different concentrations of ink can be made in white ice cube trays or individual containers by depositing drops of ink into small amounts of water. For example, take 1 ounce of water and mix in 1 – 2 drops of ink with an eye dropper. This should give a medium-pale wash; add water to make it paler and ink to make it darker.

To begin, mix pale, medium and dark concentrations, dip a brush into the pale wash, and brush over some of the dark, dry marks you made previously. Examine the visual effects of dark marks and pale washes. Play with different ways of laying down brush strokes by using the different brushes and sponges you have collected. Use the brush or sponge very wet or partially dry and notice the difference. Drip, dab, flow, brush the wash over your marks, and continue to experiment with different concentrations and superimposition of ink.

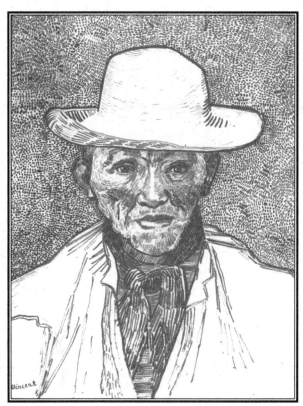

Fig. 9–5
Vincent Van Gogh
Portrait of Patience Escalier
pencil, pen, reed pen
& brown ink 1888

Apply washes of different concentrations of ink and pure water on a sheet of Mayfair paper. While they are still wet or partially dry, draw, drag, etc... pen and stick marks over the washes using dark concentrated ink. How much does the concentrated ink run (bleed) and how much time does it take for washes to dry on the page? Less absorbent papers such as Mayfair tend to buckle, and liquid may accumulate in puddles on the surface – so use a little less ink or mop it up periodically. Manila paper is much more absorbent and gives totally different effects; marks are immediately visible and cannot be rubbed off. Remember that these cheaper papers do not age well, but are adequate for student use.

EXERCISE 2

Waterbased paints such as watercolour, tempera and gouache are made from a mixture of ground materials such as minerals, insects, plants or synthetically produced colours. They are mixed with binders such as gums, glues, starches or resins. They can be mixed with varying degrees of water and applied to paper surfaces with brushes or other tools. Watercolour forms transparent washes while tempera and gouache produce more opaque consistencies. Both tube and cake formats exist, and colours can be mixed on white, waterproof palettes or trays (plastic, porcelain or styrofoam).

If you are using tube paints, squeeze .63 cm – 1.27 cm (1/4 – 1/2 ") on the palette and add a small amount of water with a brush. Make marks and washes on Mayfair and Manila papers which will give you the feel of both hard non-absorbent, and soft absorbent surfaces.

Figs. 9–6

Waterbased paints, unlike permanent inks, remain water soluble and can be easily disturbed once the brush strokes are dry. Therefore, leave desirable effects undisturbed, or dilute, scrape, and rework passages to obtain what you want. Experiment with superimposed transparent layers of paint and thicker opaque passages. Using a sharp tool to scratch into opaque areas will reveal the white of the paper and can be an interesting effect; the scratch is permanent, however.

Your repertoire of manipulations could include: adding thin or thick layers of paint, all varieties of marks, lifting off paint, scratching and scraping into it etc… Use the back side of your sheets, and when they are filled compare these experiments with your ink tests. Important qualities to consider are: transparency, opacity, gradations of tone and variety of mark.

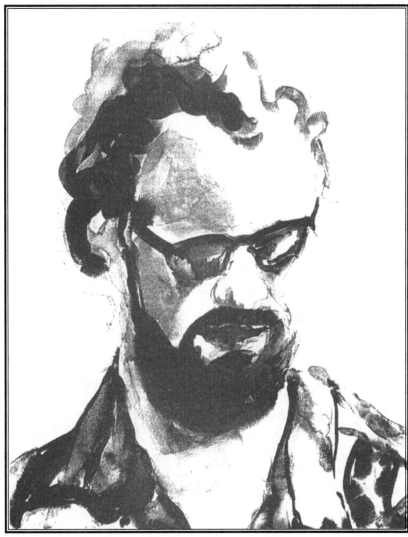

Fig. 9–7
Joanna Nash
Musician from the Beauce
watercolour 1983

MIXING MEDIA

To find out which materials mix compatibly and which resist each other, try them out together. Take all the materials: coloured dry chalks, graphite, wax crayons, ink, paint, accumulated tools and different types of paper. Play without any specific goals or intentions other than invention and discovery; experiment freely with different combinations of matter. For example: work washes over chalks, and chalks over washes, graphite and washes superimposed, ink and chalks, and wax crayon under ink or watercolour. The wax acts as a reserve and keeps the ink or paint from penetrating the paper where it was applied.

Notice what gives appealing effects. Discover and invent marks and passages of paint that can be used in future drawings and paintings. Take note of all results and begin to discern which you want to try again on clean sheets of paper.

Any mixing of materials can be attempted as long as they do not destroy the paper. Turpentine and oil based paints will rot most papers unless one or two separating coats of glue or gesso (acrylic) are applied first. If the gesso or glue is applied to both sides the conservation of the paper is further enhanced.

Figs. 9–8

STOP THE WORLD
I WANT TO DRAW IT

Fig. 10–1 Marc Chagall *To Charlie Chaplin* pen & ink on paper 1929

Some children were sitting on the steps of a church… I would begin again. Then their mother would call them. My notebook would be filled with bits of noses, foreheads and locks of hair. I decided that in future I would not go back home without having accomplished a complete work; and for the first time I tried drawing in the mass – rapid drawing – the only drawing possible. I set myself to take in a group at a glance; if it stayed in place for only a short time, well, at least I had got its character, its general unconscious character. If it remained longer, I was able to fill in more detail. – Camille Corot

Thus far we have been observing models in a studio situation where we have control over events and conditions. But the liberated artist is capable of making the whole world his/her studio, and all people potential subjects. For this reason it is important to be at ease drawing in public places. This means venturing into bars, restaurants, train stations and parks with your sketchbook open and your pencils sharpened.

Working outside the studio is very exciting and presents some challenges – specifically movement. People change positions, shuffle their feet, look over their shoulders, and disappear into the crowd. Chapter 10 will help you deal with these battlefield situations, but for the time being there are exercises that can be done in the studio that recreate some real life situations. Two models are needed for this session, preferably actors or dancers who are comfortable working together, and one or both should have long hair. You will also need an electric fan, and a couple of drinking glasses, chewing gum etc…

WARM-UP
5 minutes

Do some hand and arm exercises.

EXERCISE 1
20 minutes

SPATIAL RELATIONSHIPS

Graphite on cartridge paper and the viewer.

Arrange the easels in a large circle with the two models inside, and have them vary the distance between them in each of ten, 2 minute poses. The distances can vary horizontally and vertically if one of the models periodically sits and the other stands. At the beginning of each pose look through the viewer and establish the dimensions of the space between them. Decide if you should arrange your drawing board for a horizontal or vertical format. Do so and indicate the placement of the main masses with a minimum of detail, concentrating on the amount of space between the models. If you see the models far apart from each other, sketch them appropriately small so they and the space between them fit on your page. If their heads are close together, enlarge them to occupy the space on your page.

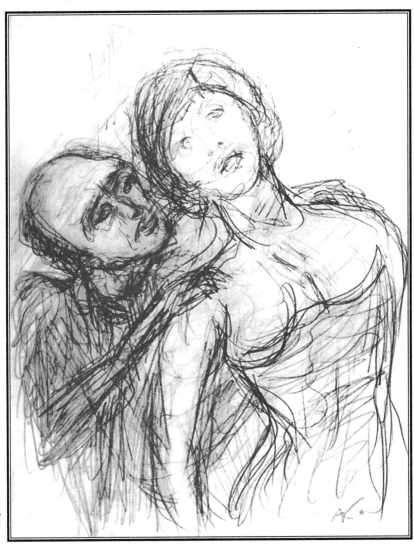

Fig. 10–2
Alfred Kubin
Man and Woman Talking
pencil drawing

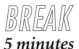

5 minutes

When drawing two or more subjects, consider their positions relative to one another. The type of distance between them can be an important aspect of the drawing. This distance can be interpreted as a physical space, as in our last exercise, or as an emotional space that communicates intimacy, alienation, or any number of relationships.

EXERCISE 2
40 minutes

Any materials and the viewer.

Have the models take two, 10-minute poses which have specific emotional content such as: talking, arguing, hugging, leaning on each other or menacing each other. In each case, whatever minimum of movement is necessary to sustain the mood of the pose or unobtrusive activity is acceptable.

Begin each pose by asking yourself what the models are doing and notice their physical proximity to one another. Feel free to exaggerate or diminish their actual size and the space between them, in order to emphasize their interaction. Then, work quickly laying in the principal positive and negative spaces and developing the models differently in each pose. For example, in pose # 1 develop one model with line and the other tonally; in pose #2 develop one model in sharp focus and the other in soft, blended tones. Find some quality in their physical or emotional state to help you choose who gets which treatment.

Fig. 10–3
Kâte Kollwitz
Woman with Boy in her Arms
lithograph 1931

BREAK
10 minutes

Walk around and look at other participant's sketches, and when a sketch appeals to you, ask yourself what you like and how the student developed the statement.

EXERCISE 3
20 minutes

MOVEMENT

Any materials.

Pose the model with long hair and give the other one a long break. Set up an electric fan on a stool or chair to the side and slightly behind the model so that it blows the model's hair around and creates movement around his/her head.

> *In this pose our intention is to show moving, streaming hai., This takes precedence over the resemblance to the model.*

Notice the energy of the moving hair and how it effects the features, perhaps it obscures them or flies in front of them occasionally. Draw the movement and let your gestures be echoed in the features. In this pose our intention is to show moving, streaming hair. This takes precedence over the resemblance to the model.

BREAK
5 minutes

Look at the resulting drawings.

EXERCISE 4
20 minutes

REPETITIVE ACTIVITY

Any materials.

Alternate the models, giving the latter one a break. In this pose the model will be asked to mime small, repetitive movements and activities normally seen in public such as one of the following: eating, drinking, smoking, nodding or turning his/her head...

For the first few seconds of the pose, observe and determine the nature of the activity, particularly its rhythm. Let it affect the way you draw. Allow the movement to influence your gestures and marks and the speed and energy of your pressure. Draw fluidly and flexibly, keep your drawing in flux, and recall the spirit of our mask-like gestural poses in Chapter 5. In this pose let yourself go, get involved in the activity, and respond intuitively and physically. Concentrate on drawing what the model is doing, not what the model looks like.

Fig. 10-4
Kay Aubanel
Ronde
conté crayon 1989

5 minutes

EXERCISE 5
25 minutes

Any material on cartridge paper.

Have both models pose differently, with some space between them, one sitting on a chair, one standing or leaning on a wall or table. Ask them to take poses which allow for a mirror image. For example, if one model crosses her/his leg over the other, s/he can reverse the legs every 5 minutes. Or, perhaps one model will look to the left then in 5 minutes look to the right etc...

Your task is to draw one model only and continue on the same drawing when changes occur every 5 minutes.

People in public places are often repeating postures from left to right. I have frequently observed them changing crossed legs over their knees as one gets tired. Or they lean on one arm while sitting, then switch to the other one when the first arm gets tired; the same pose in mirror image. Your task is to draw one model only and continue on the same drawing when changes occur every 5 minutes. The mirror image, although reversed, exhibits the same information, so the pose has not really changed and you can keep observing and drawing. If you get frustrated or lost, remind yourself that the original pose will return in 5 minutes. People in public move and the artist who is adaptable has many interesting models to draw. This challenging exercise will help you develop your visual memory.

BREAK
5 minutes

Circulate and look at the work of the others.

EXERCISE 6
20 minutes

Any materials.

Have one model sit in a chair in the middle of a circle of easels or chairs.

If the last sketch was challenging, you will really like this one. After the model has posed for 5 minutes, ask him/her to leave the circle and have the other model take his/her place in the same chair, facing in the same direction. Tell this model to spontaneously leave after about 5 minutes and have the former resume his/her pose etc… In this fashion the models will alternate 4 times during this exercise. Continue to develop the initial sketch, adding, adapting, changing as you wish. Choose any way you can to develop a drawing of one model, or more models – be ingenious, and react to the situation.

When I sketch in public and my model leaves, I usually turn my page and draw someone else. But sometimes I adapt my first subject into another one, or complete her/him by memory, adding missing information from other subjects. The artist who is adaptable has a world of subjects to draw in his or her natural habitat.

Fig. 10–5
Honoré Daumier
Study of Two Men
pen & wash

HOMEWORK ASSIGNMENT
30 minutes – 3 hours

If you have a model at home ask her/him to pose for you, reading, or watching T.V.. Or do a self-portrait. Spend some time developing your portrait, then add a second one in some kind of spatial relationship to the first. Carefully consider how your new figure fits into the existing design, and into which plane (depth) you are adding him or her – the foreground is the area in front of your original form, the middleground is the area next to the original form, and the background is the area behind your original form. Different planes effect the size of the forms; a form in the foreground is bigger than one in the middleground and one in the background is smaller than one in the middleground.

Examine what groups of people look like in books, magazines, photographs, newspapers or television, and notice how their size changes depending upon their relative positions.

You might also experiment with alternatives to the conventional use of space and scale. To help you understand some other options, examine the work of painters Marc Chagall and Réné Magritte. Consider how they arrange their space and masses and what liberties they take with conventional perspective.

THE WORLD THEATER

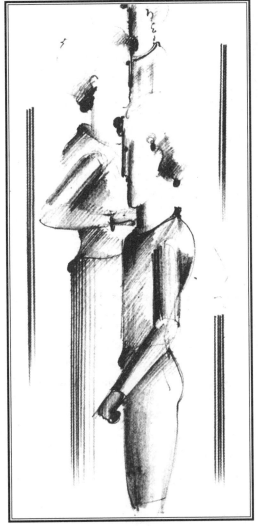

Fig. 11–1 Oskar Schlemmer *Three Figures* pencil & quill drawing 1931

I study physiognomies on my way to classes with great pleasure, trying to find quickly what's characteristic in them. When I'm talking to someone I observe diligently what kind of shadow the nose is throwing and how the deep shadow on the cheek stands out strongly and then melts into the light. – Paula Modersohn-Becker

Sketching outside is an adventure requiring confidence and subtlety. Your basic survival kit includes: a 12.7 cm x 20.3 cm (5" x 8") wirebound sketchbook, some short pencils (more discreet), a tiny pencil sharpener, and an eraser.

There are many locations where one can sketch such as restaurants, bars, parks, stations, or waiting rooms, where you have a choice of seats. Select active public places where people are moving about, sitting, reading, eating. Other possible locations are in buses, subways and cars. Eventually, we get used to the motion of vehicles and the proximity of others.

If someone is at work or at school, lectures and meetings might provide opportunities for sketching. It is important to integrate outdoor sketching into your life's schedule so that it becomes a natural activity and one with which you feel at ease. It is also very important to be discreet, to sit close enough to subjects to see clearly but not to attract their attention.

When you begin, sit from 2.4 m – 6.1 m (8 – 20 feet) away from your subject at a 45 degree oblique angle. Sometimes I lean my sketchbook on a bag or briefcase for support, and to make it less conspicuous.

When you are settled, look at the variety of people around you and find a relaxed, seated subject to whom you can get close enough to sketch. Initially it is helpful to select someone who is reading or occupied in thought or conversation. Position yourself and begin to sketch. Recall our exercises and glance at the subject, then at your page. Make an effort not to stare at them! Don't spend a lot of time thinking and planning; plunge right in and draw. Work quickly since you cannot predict the length of the pose. The more urgently you work, the more your attention will stay focused.

If the individual moves away, turn the page, look for someone else, and begin another sketch. Observe your subjects incisively: their posture, expression, clothing, the background, the foreground; tell their story in the sketch.

It takes a while to get used to the small format and the restrained hand movements and still produce lively, gestural sketches. Practice will make the task more familiar, and as confidence builds your sketches will appear more authoritative.

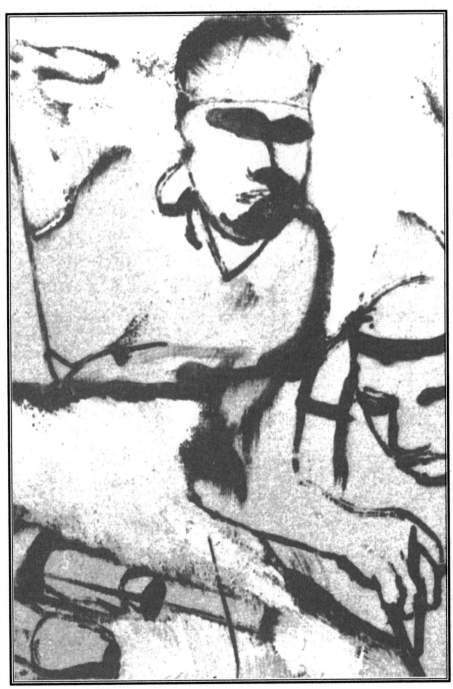

Fig. 11–2 R.B. Kitaj *Kennst Du das Land? (detail)* 1962

Work quickly and discreetly...

Absorb yourself in the activity of drawing using any of the methods you have been practicing: use line to record basic forms, rhythms and movement; use tone to show light and dark masses and enhance density and volume. In some sketches choose a focal point at the beginning and develop it throughout the drawing, in other sketches work without choosing a focus and see what evolves. Ask yourself where your subject is looking, and what s/he is thinking.

If the subject changes position all is not lost; assess the new posture and either adapt the sketch, add another model into the setting on the page, or turn the page and begin again. If the person comes back to the initial pose, turn back the page and resume the first drawing. If your subject leaves, finish the sketch from memory, or start another, or find another subject and complete the first.

Interacting groups of people can be sketched using some of the methods outlined in Chapter 9. Establish the overall grouping of the forms and spaces. Draw the overall shape of the group then subdivide into individual parts or components. Invent, eliminate, change, do anything you wish – there are no rules or limits to your interpretations of reality. Work quickly and discreetly; think of yourself as a chameleon that blends into its environment and goes unnoticed by all.

If your subject notices you looking at them, glance away; if your subject appears uncomfortable you might want to turn the page and draw elsewhere, or just stop for a few moments. If eye contact is made you are inviting social interaction and this is not your objective. If approached, be cordial and explain you are a student doing your homework. If you do not encourage conversation people usually lose interest and move on.

In public places it has been my experience that most people are self-absorbed and don't notice or care what I am doing. Remind yourself that drawing someone in public is not illegal and that artists have been doing it for centuries.

Carry your sketchbook with you as often as you can because it is very frustrating to encounter an interesting subject or situation and not have the means for recording it.

THE NEXT STAGE — WHAT TO DO WITH ALL THOSE DRAWINGS?

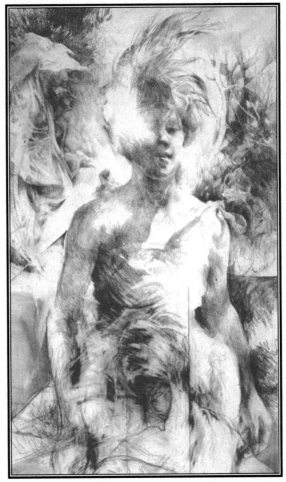

Fig. 12–1 Kay Aubanel *Jessie* charcoal & pastel 1989

No one ever heard of a great artist who was out of drawings.
Rembrandt was drawing twenty days before he died, so he could paint better. – John Sloan

Over the years I have encountered many students who idle at one level of life drawing, repeating similar sketches over and over. Perhaps this provides a safe place to stay because it does not risk any deeper research into the unkown. Artists however, need to develop and push deeper into new experiences. One way this can be done is to rework old sketches to stimulate new ideas.

Although developing old drawings is not as immediate as working from a live model, it can exercise the imagination. Leaf through some of your portrait sketches and select the ones you consider unresolved; do not alter the ones you are satisfied with. When reworking your drawing you can choose to continue the original dynamic or veer off in another direction. If you approach this research as an open-ended process you might surprise yourself and make new discoveries.

EXERCISE 1

ELABORATION

Any dry and wet drawing materials, and old sketches.

Keeping in mind the last homework exercise, add other figures or faces to the unresolved drawing: erase sections, use different materials, add or eliminate a background, develop existing images. Let images appear then disappear, then appear again. Play. The objective is not to 'finish' the drawing, but to make new discoveries and inventions that have their point of departure in the original work. If the elaboration deviates greatly and you lose all reference to the original image, let it happen. Let the drawing suggest what it needs.

EXERCISE 2

COLLAGE (papier collé)

Old sketches, a large piece of white mayfair paper, glue, and flat collage materials such as: pages from magazines, old photographs, newspapers,

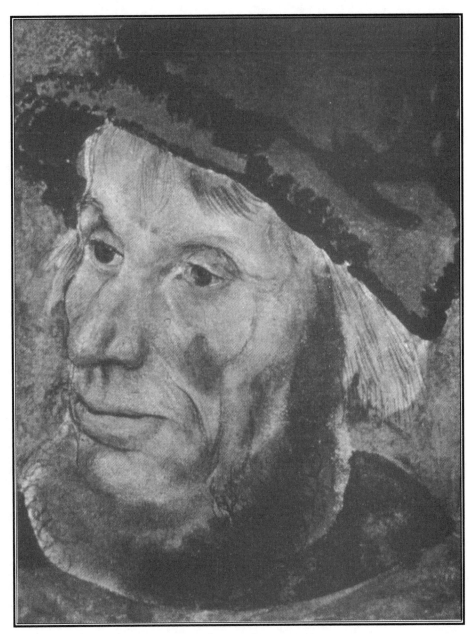

Fig. 12–2 Lucas Cranach the Elder *Study* mixed media circa 1400

Fig. 12–3
Antoine Persner
Portrait of Marcel Duchamp
1926

lables, wrapping paper, letters, sheets of music, textured fabrics, foil, and other objects (capable of being glued onto a paper surface). All your dry and wet drawing materials.

This technique involves gluing paper or flat objects to a surface to form a picture or design. Italian artists of the fifteenth century incorporated bits of glass and metal objects into their oil paintings, but it was two French painters of the 20th century – Georges Braque and Pablo Picasso – who expanded upon and popularized the use of collage.

Proceed by cutting or tearing out some faces or figures from old sketches, and arrange and rearrange them on your fresh surface. Add pieces of collage material and move elements around until your eye notices potentially interesting interactions. You can stop the collage

process at this point and glue the pieces into place. Then, step back, look at your collage, and consider how you might incorporate additional graphic elements such as chalk marks, ink and paint washes.

Draw or paint onto the collaged pieces, extending some of the compositional themes already developed and introducing new ones. Ink and paint washes, graphite and chalk marks added to the textures of glued papers begin to build up a surface and may suggest physical depth. The process can be repeated; papers can be glued onto drawn areas, and drawing can be done over collaged pieces.

Your understanding of collage will improve with time and practice. Collage can be a spontaneous, expressive technique, or the slow development of an idea. When researching in an open-ended manner anything is possible. It is only the artist and/or the materials that impose limitations. If your explorations take you away from a recognizable (naturalistic) representation of reality, go with the changes and distortions; you might find your 'abstracted' representation satisfying and can always bring it back to its original style if you wish. It is natural to the process of drawing to create an image, lose it, find it again, etc...

Trust your impulses. Play.

WHERE TO GO NEXT? THEN AND NOW

There is no specific formula for obtaining an art education; people who want to become artists are responsible for informing themselves of their options and choosing and forging their own paths.

During the middle ages, a man wishing to become an artist could be apprenticed to the studio of a master where he would receive technical instruction from that master or his assistants. He apprenticed for five to six years, rendering plaster casts in black and white and then moving on to human models and landscape subjects. His chores, while learning his craft, included cleaning up the studio, mixing and grinding colours, and filling in less important passages of commissioned paintings. Daughters and sisters of male artists were sometimes trained in the family business – this limited opportunity was the only way women could receive art training.

Private academies arose in Italy during the 16th and 17th centuries, and philosophy and art theory were taught in addition to practical

craftsmanship. In the French academies of the 17th century a male student studied architecture, geometry, perspective, arithmetic, anatomy, astronomy, and history. Although there were many limits on artistic freedom of expression, the artist had a place in society and could earn a modest living. Patrons who commissioned portraits, historical and religious works included royalty, the church, and the emerging middle classes.

Drawing was considered a desirable skill for an upper class man, although learning to paint professionally was considered an inappropriate career choice. Some upper class women also received training in drawing, but it would have been unheard of for them to pursue a professional career in the visual arts.

Although some exceptional women artists, such as Mme Viger-Le Brun, were successful in Europe, women were generaly excluded from art academies and ignored in art history accounts until the mid-18th century. When finally allowed to study art, they were restricted in their study of human anatomy and had to be content studying bovine models. Revised art history books written by women scholars after the 1970's attempt to redress this regretable omission by reinstating women artists.

The first North American art academy was formed in Philadelphia in 1794, and art programs were integrated into universities such as Harvard, Princeton and Yale.

During the eighteenth and nineteenth centuries industrialization and modernization changed art training, art production, the role of the artist in society, and patronage. Religious and royal patronage diminished and art was now viewed as a commodity. Industrial demands for artists and designers democratized art training and made it more accessible. Agents and galleries became art managers, while private collectors, museums, governments and corporations became patrons.

A variety of options exist for the contemporary adult, male or female, interested in art. A full or part-time art education is available in art schools, universities and studio apprenticeship. In each case a visit and discussion with the teachers is essential. No matter what administrators may indicate, it is the teacher who will have the most influence upon an

art student. In their favour, institutions provide programs, facilities, a choice of teachers, and courses which usually include art history, design, sculpture, photography and printmaking options.

An eclectic approach, however, is not disadvantageous and has historical precedent. Apprenticeship and free-lance studies offer an alternative for individuals who are allergic to institutional education. Careful research is required to find an appropriate teacher and the planning of an affordable personal program. Any artist who is able and willing to communicate could be engaged as a potential teacher. Arrangements can be made which might include technical demonstrations, projects, critiques and perhaps the possibility of a workspace in the artist's studio.

An accompanying risk exists for the student who may become too dependent upon an individual teacher and not have the benefit of diverse views. The pros and cons of different options need to be carefully considered, and it is important that the student make a realistic assessment of his or her time, finances and professional goals. Painting is a huge subject and artists have a tenuous position in society – the hours are long and the pay is erratic to non-existent.

One can obtain valuable information from artists about their training, career disappointments and successes. Many articulate artists wrote autobiographies and/or have had good biographies written about them. Familiarize yourself with the different realities of pursuing art as a career by interviewing artists, and researching in libraries and bookshops.

A student seeking a serious pastime as an adjunct to their professional and private lives might find satisfaction in taking adult education courses and/or joining an art group.

What is most important for the amateur or professional artist is having the courage to follow her/his heart and intuition, and to cultivate the important qualities of passion, discernment, discipline, and authenticity.

BIBLIOGRAPHY

ARTHUR D. EFLAND
A History of Art Education
Teachers College Press, Columbia University, N.Y,. (1929)

ROBERT GOLDWATER & MARCO TREVES (EDS)
Artists on Art
Random House, N.Y., (l945)

EDWARD HILL
The language of drawing
Prentice-Hall, N.J., (1966)

WILLIAM MORRIS HUNT
On painting and drawing
Dover Publications, N.Y., (1976)

MARION MILNER
On not being able to paint
Heinemann, London, (1950)

GILLIAN PERRY
Paula Modersohn-Becker
Harper & Row, N.Y., (1979)

KEITH ROBERTS
Camille Corot
Spring books, London, (1965)

JOHN SLOAN
Gist of Art
Dover Publications, N.Y., (1939)

PUBLILIUS SYRUS: MAXIMS
Oxford Book of Quotations

JENÔ BARCSAY
Anatomy For The Artist
Athenaevum, Budapest, (1958)

BERNARD CHAET
The Art of Drawing
Holt Rinehart & Winston, N.Y., (1970)

EDWARD HILL
The Language of Drawing
Prentice-Hall, N.J., (1966)

SUGGESTED READING

ROBERT KAUPELIS
Learning to Draw: A Creative Approach
Watson-Guptil, N.Y., (1966)

KIMON NICOLAIDES
The Natural Way to Draw
Houghton Mifflin Co., MA, (1941)

S. SIMMONS III & M. WINER
Drawing: The Creative Process
Prentice-Hall, N.J., (1977)

DAVID A. LAUER
Design Basics
Holt Rinehard & Winston, N.Y., (1979)

MAURICE DE SAUSMEREZ
Basic Design: The Dynamics of Visual Form
Reinhold Pub., N.Y., (1964)

DANIEL M. MENDELOWITZ
Drawing
Holt, Rinehart & Winston, N.Y., (1967)

FREDERICK FRANCK
The Zen of Seeing: Seeing/Drawing as Meditation
Vintage Books, N.Y., (1973)